Center City Philadelphia

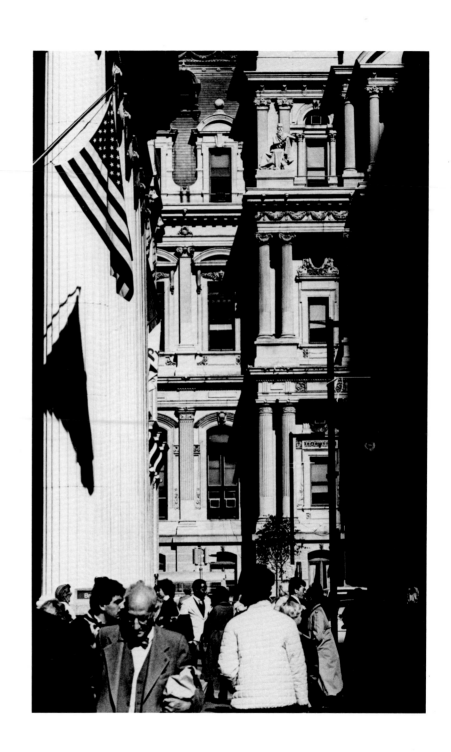

Center City Philadelphia
The Elements of Style

Eric Uhlfelder

Foreword by Lee Copeland

uᑗᑗ **University of Pennsylvania Press**
Philadelphia

Frontispiece: City Hall; South Broad Street

Designed by Carl Gross

Library of Congress Cataloging in Publication Data

Uhlfelder, Eric.
 Center City Philadelphia.

 Includes bibliographical references.
 1. Philadelphia (Pa.)—Buildings—Pictorial works.
2. Historic buildings—Pennsylvania—Philadelphia—
Pictorial works. 3. Architecture—Pennsylvania—Philadel-
phia—Pictorial works. 4. Philadelphia (Pa.) in art.
5. Philadelphia (Pa.)—Description—1981- —Views.
I. Title.
F158.7.U39 1984 779'.9974811 84-7242
ISBN 0–8122–1176–6 (pbk.)

Printed in the United States of America

To Steven, Robert, and my parents

Contents

List of Illustrations

Plates

Foreword

Photographers, like painters and writers, convey their own personal perceptions or visions of an experience. In turn, we the reader and viewer are enriched, and we expand the bounds of our own perceptions and understanding of our society and culture and the environment around us. Dickens's description of David Copperfield's London, while historical, affects our contemporary vision just as do Georgia O'Keefe's and Neil Welliver's landscapes or Picasso's and Claus Oldenberg's interpretations of their cultures.

It is common to convey more than one perception, idea, or message with a single image. And often the image, whether poem, painting, musical score, or photograph, allows the viewer a personal perception or insight relevant to his or her own personal experience and self, one not consciously controlled by the author. This multiplicity is an essential contribution to the richness and complexity we value in the works of creative artists; to see the world through the artist's eyes and mind and to see and experience that world also in our own newly discovered way carries us into the realm of creativity along with the artist.

Eric Uhlfelder did not intend this book to be a record of *what* to see in Philadelphia, but rather, *how* to see this unique, rich, mature place. Many of his photographs have a similar focus on abstracted elements of rhythm and form, patterns, texture, light, and tone. The sharp resolution of form and bright contrast conveyed is not commonly experienced in Philadelphia except during bright sunny days in the winter or early or late on certain days when the sun is low, casting strong, deep shadows. Other views convey a flatness and mergence of forms common on grey often midday, midsummer days. Certainly we develop a deeper understanding and appreciation of our surroundings when we experience the same place under varying conditions at differing times.

All vital cities, including Philadelphia, are constantly changing and exhibit at any one time growth, decay, stability, and intermediate processes of change. Center City Philadelphia contains examples of each condition within a very compact area. The juxtaposition of stability, decay, rejuvenation, and the new perceived in these photographs enriches our experience. The rate of change is very uneven in Philadelphia, affected as elsewhere by the will of property owners, purchasers, the market place, and the

city government. Buildings of common age, whether row houses, stores, offices, or institutions are in various states of change, viability, and care. Some are renewed or cared for in their maturity while others are tired, neglected, staring vacantly. Often a building, conceived of and executed at the time as a vital expression of the stature and future of Philadelphia and the vision and optimism of the original owner, stands with life in the ground floor at its base but drained and vacant in its upper stories.

One of the most important qualities found in the environments we value is a strong sense of place. We feel we are somewhere definable, comprehensible, and in place or anchored within the context. We are comforted by knowing where we are. Most often cities with a strong sense of place and with identifiable precincts within are perceived as such and valued for their uniqueness. Rome is not Paris or London, San Francisco, New York, or Philadelphia, but each has a presence, a sense of place, unique and congruent with its setting, the inhabitants, and its history.

Center City Philadelphia's sense of place is supported and amplified by being anchored between two rivers, by the rational and comprehensible original plan, by the hierarchical dominance of Market and Broad Streets and the Benjamin Franklin Parkway connecting the center to its larger metropolitan context, by its Squares, by City Hall, and by its history, especially Independence Hall and its surroundings.

Center City is an unusual name for a downtown. Are there any other downtowns called by this name? The term itself contributes to a sense of place, the center of the city. Whether it is actually the center or not is unimportant; it is certainly perceived as the center of Philadelphia. The use of the term is relatively recent, probably applied since the 1940s, and may be derived from Center Square, the original name of the Square where City Hall sits. The bounds of Center City vary depending on one's distance from the center and familiarity with areas within the center of Philadelphia. Its boundaries have expanded with the growth of the office precinct and with the renovation and revitalization of retail and residential areas. However, the boundaries have in some sense contracted with the labeling of other areas seeking their own identity or place within the central part of Philadelphia. "Old City," "Logan Circle," "Parkway," "Franklin Town," "Rittenhouse Square," "Fitler Square," and "Society Hill" are places within the central area, some within Center City, others not, depending on one's perspective and inclination.

A sense of place is also amplified by contrasting a distinctive area to areas in between without unique identities. Often these areas are in transition, perhaps rundown. The contrast heightens one's awareness of neighboring places with strong identities, and the in-between areas may reflect some of the attributes of the

places bounding them. As in-between areas they provide opportunities for marginal activities and for inhabitants who wish to live on the edge, to observe from the outside, or who cannot afford the higher cost of centrality. Many businesses find it advantageous to begin in these areas as a way of trying to establish themselves. Others, such as printers or architects, volunteer to stay in these areas, close to their clients, paying lower rents than in the center. Many of the photographs here include buildings in the foreground and the background with in-between space in the middle ground. Part of the richness of Center City Philadelphia is in the proximity of a complex array of places and transitory or in-between areas.

Eric Uhlfelder, as author/photographer, conveys here also a plea for the conservation of buildings and the preservation of a sense of Philadelphia's history. Uhlfelder's selective eye focuses on the richness of detail, form, and variety found in the historic fabric of Philadelphia but often absent in our contemporary buildings. In other instances, by close juxtaposition, he illuminates the complimentary nature of the new and the old, fitting together more comfortably in Philadelphia than in many other cities.

One delights in experiencing a variety of scales, images, and forms simultaneously. The pictures frame composite views of similar scale and shape whether of the same age or not, but then individuality emerges and a richness and complexity unfold, often magnified by the detailing in older buildings. The curves, reveals, decorative forms, and changes of planes within surfaces found in older buildings often age well too. Over many years the accumulation of dirt and water stains gathers in the indentations, heightening the contrast in form, further sharpening the presence of decoration and detail. The architect and craftsman knew the potentials and limitations of the materials available. They used appropriate restraint, but also took joy in stretching the limits of materials, experimenting, and surprising and educating the viewer with their creativity where the usual was applied in unusual ways. Today architects are once again searching for contemporary ways to include decoration and recreate the richness we enjoy in our historic buildings.

Uhlfelder's views are taken through the eye of the pedestrian, and it is from that vantage point that Center City Philadelphia is most enjoyable. While the volume of traffic is great, vehicles do not dominate one's experience. The narrow streets and spaces bring the finely detailed, rich buildings and trees into a closer, dominant relation to the pedestrian, overpowering and diminishing the presence of automobiles and their movement. Compare the streets of Center City with any suburban commercial artery or with the wide avenues of New York where building and landscape recede and the rushing traffic dominates. There is a congruence or fit here between the pace of the pedestrian and the intimate

scale and richness of the surroundings, of the street spaces, buildings, and landscape. Center City is intense, vibrant, alive and calm, peaceful and mature. Eric Uhlfelder conveys these qualities well and inspired me to see more sharply.

Lee Copeland

Center City Philadelphia

Center City Philadelphia: The Elements of Style

This book is an essay on the visual character of Center City Philadelphia. It is as much a description of a particular city's image as it is a study of elements composing the design of cities everywhere. What inspired this book was not Philadelphia but what I saw in Philadelphia. Instead of focusing upon the landmark architecture that defines Center City's heritage, this study looks at the more common pieces of the streetscape to reveal the character of a very special place.

Its concern goes beyond the kind of architectural criticism we read in newspapers, journals, and guidebooks. Rather, the discussion focuses on the visual product of contiguous development. No matter how clever an individual design may be, regardless of its technological accomplishment, a building in a city is only a single part of a larger order; how it enhances or detracts from the surrounding environment is to me the essence of architecture. A building must assuredly serve its clients. However, pedestrians are most affected by its presence, and their experience is largely defined by the aesthetic quality of each block's structural composite.

The study of streetscape as aesthetic form is hardly new. Artists from the Renaissance to Utrillo, from the seventeenth-century European View Painters to the twentieth-century Ashcan School, to Hopper's and Estes's romantic and photorealism all realized the artistic nature of our cities' streets (Fig. 1). While always realistic, my perspective ranges from abstract to architectural. I see a wall enclosing a street as much as it does a room; a stoop as a geometric form; street lights, sidewalks, and benches as landscape (Fig. 2). The elements of the street read to me as lines and patterns that vanish to points. I see the city less as a functioning entity of buildings, roads, and squares and more as a linear and sensual conglomeration that sometimes forms pleasing compositions.

The quality of this critique lies in its use of photography as an aesthetic measure of street design, in identifying portions of the city that are especially pleasing to walk. The process of finding good compositions revealed to me the elements of good urban form, to the point where I would sense a special street scene by

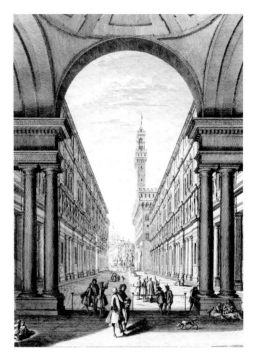

Fig. 1. Renaissance Florence. Drawn by Giuseppi Zocchi, engraving by Giuseppe Vasi (Courtesy of Edmund Bacon)

Fig. 2. 1900 block of Walnut Street (Plate 1)

Fig. 3. Delancey Street; east from Eighteenth Street (Plate 2)

noticing the juxtaposition of specific elements such as cornice lines, shadows, detail, and space.

Collectively, the photographs illustrate Center City's sequential and random order that speaks of an almost organic design, as I think of it, that enables the experience of discovery to be as fascinating as the scenes that evolve.[1] Busy commercial streets resolve into residential blocks and alleys; one can be towered over by skyscrapers one minute and delightfully lost in the quiet elegance of a labyrinth of intimate streets the next. What unfolds from this study is an appreciation of an important aesthetic theme that not only gives Center City a sophisticated flavor but also characterizes much of the American urban scene: diversity within order (Fig. 3).

The appearance of many of America's older and larger cities tells us that their growth occurred spontaneously. Though usually guided by a formal street system, development proceeded with almost mitotic abandon, advancing in all directions, adding layer upon layer, backtracking to fill in the empty spaces as they proved valuable enough. Certainly, before attempts were made to regulate the general appearance of streets and neighborhoods, existing structure suffered aesthetically and functionally from new development that was loud and obtrusive. Yet when developers sought grandeur rather than just attention, the same bold, uninhibited approach to building created visually exciting scenes. Georgian row homes could be found next to Second Empire apartment houses, which in turn could be found next to Italianate department stores. And though this composition may not suggest a particularly appealing image, especially as these buildings stood increasingly in the shadows of lofty hotels and office towers, it was this continuous evolution and mixing of unpredictable shapes and designs that made the bizarre order of the nineteenth-century street interesting, if not exciting.

Then sometime early in the twentieth century this kind of visual complexity could be seen giving way to more severe com-

1. Though used here in a less traditional manner, the term organic effectively expresses the feeling of many of Center City's streets. Architecturally, the term refers to a vertical relationship between landscape and structure, a unity which Frank Lloyd Wright made famous. I think of its intrinsic meaning much in the same way except turned on its side, as it were, to describe the flow of the streetscape. In suggesting a composition of almost "natural" evolution, an organic streetscape involves the continuity of certain patterns and moods established by cornice lines, windows, walls, horizontal bands, ground floor design and use, and the spacing between these elements. Lewis Mumford wrote: "Organic order is based on variety, complexity, and balance; and this order provides continuity through change, stability through adaptation, harmony through finding a place for conflict, chance, and limited disorder, in ever more complex transformations." (Lewis Mumford, *Architecture as a Home for Man* [New York: Architectural Record Books, 1974], p. 185.)

positions. Where richly detailed facades once looked out, blanker walls began appearing. Builders were developing and redeveloping land with greater efficiency. Whether parcels were being consolidated for large building, or boxlike structures were being erected to utilize more air space, the streetscape was becoming more monotonous. Intensifying demand for urban real estate brought about fundamental changes in many cities as the movement toward a modern architecture began to take hold.

Today many of our older buildings and spaces are greeted with increasing respect, in large part because their designs reflect a lost art of building. The richness of premodern architecture (Fig. 4), a century-and-a-half-long era referred to collectively by one architectural historian as Picturesque Eclecticism, makes many buildings seem special, sometimes when their designs really are not.[2] Even those façades overladened with detail speak of a sensitivity to the human spirit that mid-twentieth-century architecture as a whole does not convey. The current rehabilitation and preservation movement expresses a growing appreciation for the remaining pieces of irretrievable building that once prolifically embodied our architectural heritage.

However, we are still losing the buildings and spaces that distinguish one city from another in terms of history, values, and purpose—in terms of character. Modern architecture does not possess an indigenous quality, communicating instead in an international idiom that reflects the sharing of technology and an indifference to place. And its larger pieces suggest a permanence, marking a decline of the city's dynamic character both physically and culturally, leaving a scale less kind to the pedestrian.

Center City is the geographic, economic, cultural, and historical center of Philadelphia. It lies between the Schuylkill River to the west and the Delaware River to the east, with the other edges of its rectangular shape defined by South Street to the south and Vine Street to the north. Center City stretches two miles east to west and one mile north to south. Like most of Philadelphia, its streets are organized in a grid. And though its name is synonymous with downtown, Center City is a heterogeneous composition of residential, commercial, municipal, industrial, and historic districts.

Fig. 4. 2300 Locust Street (Plate 18)

2. Carroll Meeks, through his analysis of the railroad station, asserts the existence of a general style of architecture between the last decade of the eighteenth century and the second decade of the twentieth century when revivalisms and neoisms indicated to many a stylistic step more backward than forward. Picturesque Eclecticism is defined by variety, movement, irregularity, intricacy, and roughness—a synthesis of design motifs that understood beauty as a dynamic concept that changes and reflects the spirit of the times. See Carroll Meeks, *The Railroad Station* (New Haven: Yale University Press, ca. 1956), pp. 1–25.

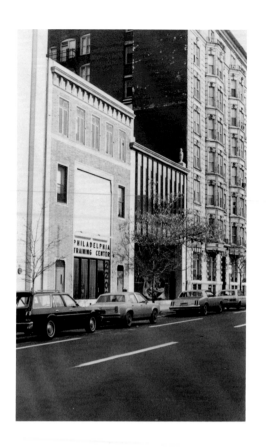

With its stone skyscrapers, large hotels, elegant shops, and bustling streets, Center City possesses the aura of a big city. Yet it retains a remarkable portion of its physical past. Some sections have changed considerably: the area where Society Hill Towers stand, the Market Street-Broad Street commercial corridor, Rittenhouse Square, and the entire stretch of the Benjamin Franklin Parkway. But even after the current renewal efforts are completed, well over half of Center City will remain three and four stories tall, retaining the inherent charm that an eighteenth- and nineteenth-century building stock preserves.

Center City is a special place. It is a collection of neighborhoods, composed of comfortable, sophisticated, and intimate streets. It is dotted with rustic enclaves that defy existence in a big city, and though it is a dynamic place, Center City so far has been able to escape the traps associated with metropolitan life. Its streets are for people. Whether as the result of Quaker influence or a genteel developers' market, the streetscape does not subordinate the town's residents. Tall buildings do not fracture the area's quiet character because they are almost exclusively restricted to major avenues, corner lots, and open spaces. Meanwhile the renovation and construction of townhouses are reinforcing the existing scale and design of the street. Growth and preservation have been effectively linked so that we often see the private sector pursuing development that enhances the city's personal qualities.

Fig. 5. Building design within the streetscape:
a. Individual: 2200 block of Chestnut Street *(upper left)*
b. Unified: 2102–6 Spruce Street (Plate 32) *(above)*
c. Composite: 2000 block of Locust Street (Plate 3) *(upper right)*

4

But there is a more subtle level of visual interplay going on here. The layering of buildings from centuries past preserves the styles and values of past generations and produces splendid and unexpected contrasts. Finding well-cared-for plants draping down fire escapes of nineteenth-century lofts, walking across graceful stone bridges that most think of crossing only in cars, browsing through a bookstore on the ground floor of an old townhouse, discovering an alley that has preserved a scene a century old, or watching an entire manufacturing district being refitted for family use; these are the visual pleasures that remind us the city is for people.

The character of a city is found in the richness of its streets; their scale, continuity, function, and use determine whether walking along them will be a pleasurable, uncomfortable, or indifferent experience. In a general sense we can discern two dimensions of a street. First, the space it forms creates the context of the social city where neighbors mingle, business is conducted, and communities are formed. Second, the walls defining these spaces compose the aesthetic city. The continuous rows of buildings of varying design and texture form a backdrop to city life. The streetscape, more than any other element, defines the physical and sensual character of a city.

The visual character of a street can be broken down into several components: structure, detail, and space. Buildings are generally seen as individual or unified forms (Figs. 5a, 5b); particularly attractive buildings can be seen as both, as detail gives character while texture and dimension seek continuity with adjacent buildings. (Fig. 5c).

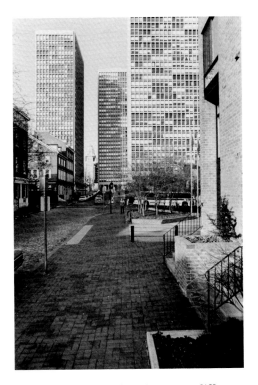

Fig. 6. Space can help to integrate different scales of building; Second Street, north from Delancey Street

5

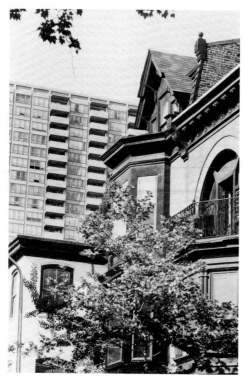

Fig. 7. South Twentieth Street; north from Delancey Street (Plate 49)

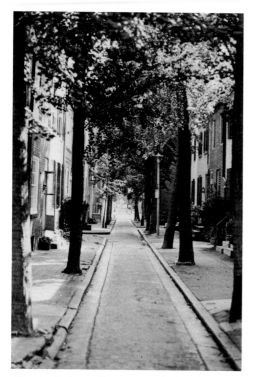

Fig. 8. Quince Street; south from Locust Street (Plate 13)

By the way it defines space and vistas, development can encourage curiosity and increase awareness of one's environment. It can create new spaces and aesthetic walls to enclose them or strengthen an existing quality, such as a visual corridor, by reinforcing it or by acting as a visual terminus. If possible aesthetic impact is neglected, development can disrupt a streetscape by attracting attention to an unworthy site, or, by refusing to maintain an existing street wall, it can cause an avenue to leak visually.

Buildings need not be commonly or anonymously styled to fit into an existing order. Architectural detail, whether a sculptured addition to a façade or a pronounced cornice, can link diverse designs by jointly enhancing a street's visual texture; it enriches a street, giving it a greater sense of depth. In viewing a streetscape I see it initially as a composition of volumes differentiated by shape, mass, surface quality, light and shadow, and depth as defined by vanishing lines and space. Though these built and unbuilt volumes register quickly in my mind, they themselves do not necessarily invite further observation. In the same way a stray motion can catch our eye in the confusion of a rush-hour street scene, detail—like a building's capital or the entablature of a door or window—attracts our attention. It differentiates similarly sized volumes by adorning each with particular character, suggesting that detail is really at the center of our focus, perhaps as much as any other element of a building's or a street's design.

The balance between structure and space is critical in establishing a visual pattern. Just as important as the subjects on the painter's canvas is the space that separates them, allowing them to breathe or be stifled in congestion, producing a sense of distinction or commonplace. A composer understands that a theme can be strengthened when surrounded by distinct, supporting composition. The character of almost any subject, be it animate or created, is largely defined by its placement in the environment (Fig. 6).

Space is a key ingredient of perspective, not only in the way it relates building on the street level but also in the way it relates and is defined by building design above (Fig. 7). Because of the distances between them, one building actually shapes portions of others beyond it, slicing away chunks, hiding vertical and horizontal edges behind jagged slants. From this perspective the space separating these buildings then seems to collapse. The walls in the scene become independent of their buildings. They "form" and "cut" new shapes that draw the sky, and all of its diversity, into a composition that no longer reads as disparate parts.

The dynamic relationship between enclosed and open space, the experience of being enticed along by evolving vistas, channeled through narrow streets into an unexpected square or plaza, is a special quality of a city (Fig. 8). It intrinsically involves the

pedestrian in the design of a city, offering an experience that goes beyond the brief pleasure that individual sights can offer. For the physical complexity of the city to be a visual asset, builders have to appreciate the value and effect that space has on the built environment.

Though we can agree upon the basic elements of the street-scape, if we were to walk a particular block together, we might well find ourselves reacting differently to what we saw. Our sense of beauty, scale, proportion, and propriety differ and hence so do our responses.

Response to a place may be shaped by a knowledge of its development. I might find Walnut Street appealing, but an older person who knew it when it was lined with mansions and elegant townhouses might not find the street as attractive today. The converse can also hold true. Where one may feel that the redevelopment of Market Street West has left it looking antiseptic, another may appreciate how the sleek new skyscrapers have breathed a modern and efficient air into a worn section of the city (Fig. 9). Awareness of the changing character of a place affects our response, enabling it to go beyond what we see.

Essentially, however, the "rhythm" created by architectural details, the "allusion" of images, and the feeling of other such moods and thoughts allow us to understand our response to the built environment. And this awareness allows us to identify the scenes and order of the city worth preserving and reinforcing. These ideas, described below, link the physical experience of the city with its visual appeal; they are the elements that make us feel we belong.

Warmth

Whether felt from the sun, a park, or a small street tucked away from the activity of the city, warmth has a soothing quality; it is the essence of Center City's appeal.

Material, size, and space are elements of building to which we respond. The difference in texture between a brick building and one made of wood elicits different feelings. We can be impressed by a skyscraper, but we can begin to know the residents of row homes through the individuality they impart to their homes, in the color of the façade and trim, in the care of the sidewalk in front, in the plants that grow from the window sills. It is the touch of human character that gives inanimate objects warmth.

Warmth depends upon the enclosure of space that is scaled and molded for people, not merely defined. Penn Center Plaza (Fig. 10), located just west of City Hall, is a well-defined space, but it fails to evoke much emotional response because of its nearly exclusive commercial focus. Washington and Rittenhouse Squares,

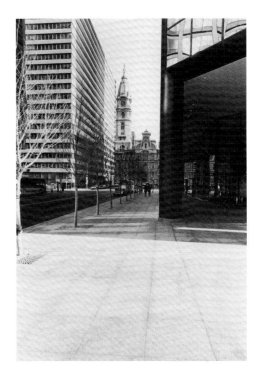

Fig. 9. Market Street West

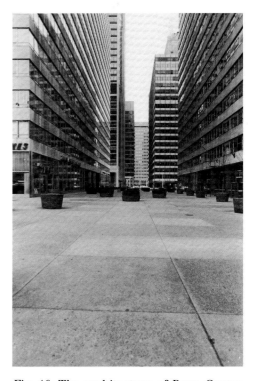

Fig. 10. The architecture of Penn Center Plaza

7

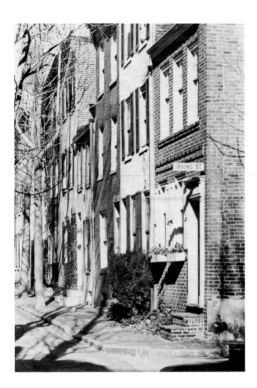

Fig. 11. Quince Street; north from Irving Street

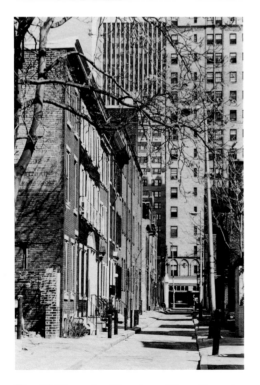

Fig. 12. Moravian Street; east from Twenty-first Street (Plate 42)

on the other hand, are perhaps Philadelphia's most elegantly designed spaces: richly landscaped, tailored for the pedestrian. The warmth we feel in these squares, however, is different from the warmth we feel along certain small residential blocks; the sights and disturbances of the city intrude in the former spaces while the latter offer a more insulated and personal experience. South Quince Street (Fig. 11) is a small, discontinuous road, and the portion between Locust and Spruce Streets feels almost like an extension of the residential living space of the nineteenth-century two- and three-story brick row homes that line the street. The trees along both sides of the street have grown tall, and their upper branches have joined and have formed an arcade. Shrubbery adorns the façades of each home, which, in their collective posture, seem almost to socialize with one another. The space is intimate, the mood serene. People seem to feel very much at ease here, and the resulting atmosphere makes for a warm experience.

Random Complexity

Much is revealed about a city's development in the odd mix of building types where stone and brick horizontal edges collide with the vertical rise of glass and steel structures (Fig. 12). Contained in a basic order are expressions of independence and confusion that form a picture of the underlying discord in society: of differing and often conflicting individual desires and the effect they have on the collective image. Yet the truth expressed in this visual complexity possesses an aesthetic quality.

An environment that is too completely organized appears shallow in comparison, lacking spontaneity and a dynamic quality. If we find nothing out of place and if everything we see seems to have been foreshadowed, then our senses become dulled. Rapid redevelopment of an area can often lead to excessive aesthetic uniformity, which characterizes Penn Center Plaza (Fig. 10), robbing the street of the diversity of form and detail that gives older, integrated streets fluent visual pace.

If we can be surprised by finding a small park, like Fitler Square (Plate 64), where buildings are expected to be, or in seeing Thirtieth Street Station pop into view along South Twenty-sixth Street or the Benjamin Franklin Bridge emerge from the structural confusion of the Old City's loft district (Plate 23), then the random, fortuitous order of the environment becomes appealing.

Planned environments are capable of achieving similar effects. An informal walkway (Fig. 13) stretching through courtyards, gardens, alleys, and playgrounds connecting the Second National Bank on Fifth and Chestnut Streets with St. Peter's Church on Third and Pine Streets was devised during the redevelopment of Society Hill. There is little to indicate this natural flow of space

Fig. 13. Walkway connecting Walnut and Locust Streets, between Fourth and Fifth Streets

was planned. But where this walkway succeeds, most rebuilt areas tend to look more polished than composed and fail to achieve that dynamic appearance often seen in the random order of our older streets. And this failure largely explains why new areas so often do not connect well with older ones.

Discovery

I did not expect to find what I did in Center City; the appeal of her streets is as much in finding them behind an understated image as in their actual beauty. But the richness of Center City is in discovering its layers of historical and aesthetic depth.

Less than a century ago Dock Street was the heart of the wholesale district (Fig. 14a), "dense with markets, warehouses and vehicular traffic."[3] That activity is incongruous with the quiet, loosely defined, closed street it is today (Fig. 14b). As the only curvilinear street in Center City, Dock Street must have been more interesting to walk along in 1895 when it was built up. Yet knowing it has undergone such a radical change gives its present appearance a more dramatic quality than would be expected.

The contrast between what we see and what once was along Dock Street is less evident along the Benjamin Franklin Parkway, even though the latter's twentieth-century metamorphosis was far greater. Because it was such an innovative and extensive plan that

3. Robert E. Looney. *Old Philadelphia in Early Photographs* (New York: Dover Publications, 1976), p. 22.

9

Fig. 14a. Dock Street, 1895 (Courtesy of Robert Looney, Free Library of Philadelphia)

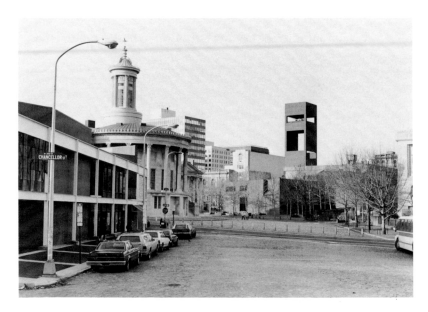

Fig. 14b. Dock Street, 1983

came out of the City Beautiful Movement of the early twentieth century, the Parkway left little trace of the neighborhoods it erased, suggesting it was part of Penn's original plan. However, noting the way the Parkway differs from the rest of Center City reveals its distinct history, the way it broke with the order and tradition of development in Philadelphia. Subsequent building

10

along it has been mostly independent of the street and adjacent structure (Fig. 15). This includes the way in which the large pieces of adjacent classical building relate to Logan Square, which the Parkway transformed into a somewhat isolated circle. There is often discord in the way buildings along crossing streets meet the Parkway; the sharpness with which buildings turn corners in Center City cannot be duplicated as the size of the Parkway requires a new scale of building for the traditional streetscape to be reestablished.

Anticipation is very much a part of the pleasure of discovery. Center City's unbroken street walls, in maintaining a tight view, keep the scenes contained along crossing streets hidden until our eyes turn the corner. A grid foretells an order, but the unexpected variety and intersection of Center City's streets—from its pedestrian ways, small discontinuous streets, to its commercial avenues and six-lane boulevards—offer rapidly changing vistas that make discovering this portion of Philadelphia a delightfully unpredictable experience.

Perhaps one of the most unexpected discoveries is found in the middle of town where instead of an intersection we find the tallest building in the city around which a variety of street scenes evolve: the canyonlike feel of South Juniper Street, the grandness of South Broad Street, Penn Center Plaza's pedestrian mall, and the breadth of the Parkway.

A more specific kind of discovery is in noticing the subtleties of design that affect our perception. A grand staircase unwinds symmetrically onto South Broad Street from the second floor of the Union League Building (Plate 35). By having removed the

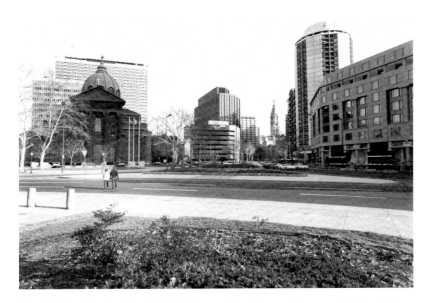

Fig. 15. Benjamin Franklin Parkway; from Logan Square to City Hall

11

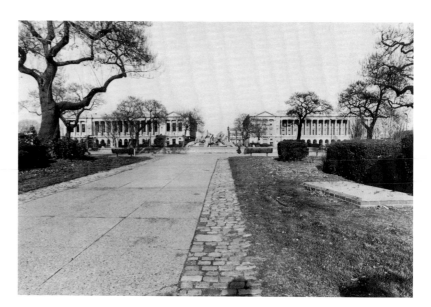

Fig. 16. Logan Square: The Free Library of Philadelphia *(left)*, and the Family Court Building

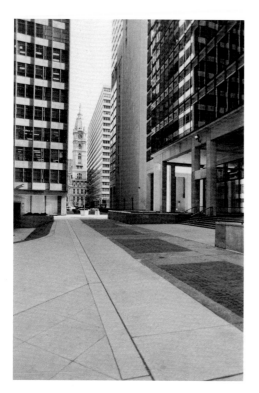

Fig. 17. City Hall; looking east through Penn Center Plaza from Seventeenth Street

staircase from inside, the architect has done more than design a graceful public sculpture: he has transformed the act of ascent and descent into a public event. The homes along the south side of the 1900 block of Pine Street (Plate 19) and the 900 block of Spruce Street, known as Portico Row, demonstrate a row design's effect on the appearance of individual buildings and streetscape. When buildings in a row are symmetrically paired by sharing a common stoop or portico and fenestration, the unit scale of the row is subtly doubled, creating an effect an individual building cannot make, adding a certain grandness to a street that essentially is not much different from most other blocks.

We can ultimately discover the character of a street, not just by knowing its past or the forms that compose it today, but by seeing the poetry and humor and metaphor in its detail. There is the Sage looking down on South Broad Street from his perch on City Hall's third floor (Plate 11). Lions can be found guarding homes while gargoyles keep a watchful eye over some of the streets. And key-shaped doorways, like the one at 2408 Pine Street, tell us from a distance where and how to enter.

Allusion

To the north of Logan Square sits the Free Library of Philadelphia and the Family Court Building (Fig. 16). They are classical buildings of nearly identical design: the main façade of each is dominated by a row of very large corinthian columns, four of which

project out from either end of each façade, crowned by a classical pediment. Because of the strong allusion to the Place de la Concorde, the setting has a grander feel than if the buildings had been designed or arranged differently.

Our perception of beauty, creativeness, and progressiveness is based more on examples stored in our minds than on theoretical conceptions. (Perhaps this explains why appreciating non-traditional design is sometimes difficult.) A building or a space may appear attractive because of a suggestive allusion as much as for its design. Light, color, texture, and detail can also conjure thoughts of absent images even when the overall composition of a site does not.

In the way it sets aglow her soft pastel colors, many regard the natural light in Paris as the city's most identifiable quality. When the sun duplicates this effect somewhere else, it can kindle thoughts of the city, even when little else around does.

Allusion can be drawn from basic forms. A row of four-story brownstones occupies the south side of the 1500 block of Pine Street (Plate 33), and for me the feeling of having wandered onto a New York street is inescapable every time I am there.

Recreating the motifs or design of an attractive site, in a proper context, creates a dramatic effect. Yet architects feel more vulnerable to criticism when borrowing from landmark buildings than from bland, common designs like a glass box. Ultimately, design is less a matter of ethics, more an effort to improve the appearance of the environment, and if an architect recognizes aesthetic worth in making reference to a past accomplishment, then he should be applauded for putting the public's senses ahead of his ego and the opinion of critics.

Fig. 18. American Baptist Publication Society Building (b. 1899); west from Broad Street: gem of a skyscraper now contained within an unsympathetic streetscape

Boldness and Understatement

Expressive, dramatic architecture makes our streets special and gives them identity. Modern architecture excels in making bold statements. Its best works tend to be monumental, sculpturedlike designs that succeed visually by being physically set apart from the streetscape. Had Society Hill Towers (Fig. 6) been built in typical lots within its row-house neighborhood rather than in its small, parklike setting, their incompatibility would have been greatly accented and their appeal reduced. Likewise, buildings that make strong statements can make the more mundane adjacent architecture visually effective. The simple designs of some of the buildings near the intersection of Broad and Market Streets serve as a collective foil that highlights the extraordinarily ornate City Hall (Fig. 17).

Skyscrapers tend toward pretentiousness—even though it is not an inherent quality of tall buildings. Many of Center City's

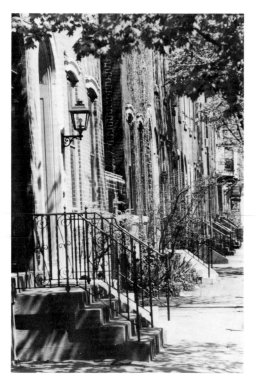

Fig. 19. 2100 block of Pine Street; north side (Plate 40)

older skyscrapers, particularly those along Walnut and Chestnut Streets near Broad, do not pounce upon a pedestrian's senses. As opposed to designs that clamor for attention, their reserved quality is due to sensitive street-level design and intelligent placement in a predominantly low-rise city. When one strolls along Chestnut Street and looks up at the magnificent capital adorning Frank Miles Day's American Baptist Publication Society Building (Fig. 18), one discovers an understated beauty that makes for good architecture.

The preservation of Center City's row-house district illustrates this theme more effectively in a larger scheme. We can walk along parts of Pine and Spruce Streets, block after block, feeling very comfortable without taking note of any particular building (Fig. 19). The uniformity of townhouse design creates a streetscape of quiet elegance. We sense a balance, an evenness in the flow of structure that is not disturbed by oversized building or discordant design. Our attention does not wander: vistas are smooth. These subtle qualities may go unnoticed when the repetition of building design, rather than the product of a homogeneous streetscape, is focused upon.

REPOSE

The most extraordinary quality of Center City is that at one minute one can be in the heart of a bustling downtown, meeting with a bank executive in a thirty-story skyscraper, or attending the symphony in one of the world's most famous music halls, and in the next minute, be in a quiet enclave of intimate streets whose mood is more rustic than urban. The proximity of these two experiences offers pedestrians a way of leaving the pace and tension of the city, and residents a surprisingly uncompromised place to live, just a minute's walk from business and cultural institutions.

South Broad Street is the address of City Hall, the venerable Union League, major banks and hotels, and the Academy of Music, all located within four blocks of one another. Just east of Broad Street lies one of Center City's many intimate, residential labyrinths, composed of six-foot-wide streets and small brick homes (Fig. 8, Plate 14). The place is peaceful and its contrast with South Broad Street remarkable.

RHYTHM

There is movement in all architecture, in its parts, as displayed by the elements of the Victorian townhouse, or as a whole, as seen in the clean vertical thrust of the modern skyscraper. Generally a street looks appealing if there is a perceivable rhythm between its individual buildings. To sense rhythm is to find order: it is the

repetition of an element or a motif in a building as well as in the streetscape that helps unify appearance. Specifically it may involve fenestration or detail, height, or the spacing between buildings.

Rhythm is well illustrated in the Free Library's corinthian columns and in its row of arches. In the latter element, your eyes run up and around each arch, arch after arch, in the same way the architect's pencil did when he first put them to paper (Fig. 20, Plate 31). As is the nature of observing dynamic form, rhythm intensifies and resolves as one's physical perspective changes.

Rhythm is partly defined by the speed at which our eyes flow along a surface. When looking tangentially along a façade, we can observe how textured surfaces and projecting elements of historically styled buildings give pace to our vision. The smoother surfaces of modern design tend to look slick; our focus slides off the façade more quickly because modern architecture's search for a distinctive appearance through minimalistic and technological expression eliminates eye-catching detail. This difference between historical and modern designs is simply that modern building creates a rhythm of a different meter. Yet in doing so, the visual significance of modern architecture is made more extrinsic, acting as a foil in sliding attention to adjacent pieces of more interesting design.

Rhythm is an aesthetic means by which a block of buildings can be unified. Once again consider the row of brownstones stretching along the 1500 block of Pine Street (Plate 33). If only one stood there, the visual quality would be found in its design. In being grouped together, windows, pediments, and cornice lines become unified on the scale of a full block. Rhythm flows along each level of the structures, and a dramatic streetscape is created.

City Hall is a good example of rhythm found in an individual building (Plate 29). Its windows, pilasters, and columns establish vertical and horizontal cadence (though not as spontaneous as in a row of buildings), effectively expressing pattern and order.

On a larger scale, the juxtaposition of buildings of different heights, as seen when looking eastward from Twentieth and Sansom Streets (Fig. 21), may suggest confusion, but in the progression of levels there is harmony.

Fig. 20. The Family Court Building *(foreground)* and the Free Library of Philadelphia; west along Vine Street from Seventeenth Street

NATURE

America's master park builder Frederick Law Olmsted saw parks as the lungs of a city. Certainly the scale of open space conceived by Olmsted was usually far greater than the squares of Center City, but given that it is the downtown of a major city and only two square miles in size, Center City is endowed with a civilized amount of green space.

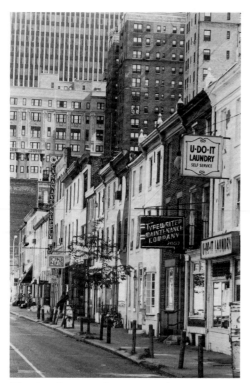

Fig. 21. Sansom Street; east from Twenty-first Street (Plate 37)

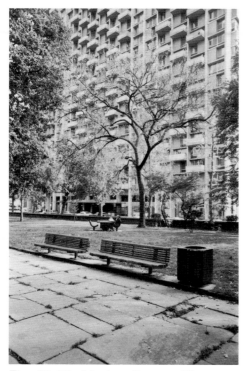

Fig. 22. Washington Square. The most restful of Center City's major squares

Center City's first planner envisioned a *green country towne*, and though William Penn's dream of large single home lots was quickly compromised, it could be argued that his concern for nature in the city has endured. On the east side of town along Sixth Street there is a mile-long greenway containing a variety of open spaces, extending from Franklin Square, around Independence Mall (Plate 15), and diagonally to Washington Square (Fig. 22). On the west side of Center City, Rittenhouse Square prevents development from stretching uninterrupted from Washington Square to the Schuylkill River. And in the northwest quadrant, the Beaux-Arts design of Logan Square (Plate 12) incorporates European landscape motifs in helping to extend Fairmount Park into the city.

Though isolated instances of nature cannot "cleanse" pedestrians the way Olmsted envisioned large parks could, they do offer relief. A small square or a garden wall may not give the illusion of a rustic setting, but it does soften the built environment by diffusing the harshness of structure and by humanizing what is artificial. This not only soothes the pedestrian psyche but also offers interesting visual contrasts.

HOPE

This attitude, more abstract than the concepts previously discussed, requires experiencing a place for a period of time in order to understand. When a block is renovated, when an empty lot is made into a small park, or when new buildings look good, people may begin to feel that their community is getting better and may view the environment with a more positive eye (a perception of significance for a city when sensed by investors).

Since the 1950s Center City has experienced widespread improvement, seen foremost in the revived quality of its lowrise housing stock. The preservation of much of Center City over time has made it the home of some very old architecture. Historic certification has resulted in the tasteful restoration of many buildings that serve as models for private renovations. The popularity of Society Hill Towers (Fig. 6)—a development that broke dramatically with the existing fabric of the community—suggests its successful integration into a charming community. Because development along it continues and because it endures as a bold conception, the Parkway can be seen as a contemporary improvement that is considered one of the city's treasured possessions. And in the Old City, east of Fifth Street between Chestnut and Vine Streets, another large-scale improvement can be witnessed. The ongoing conversion of many of its lofts into homes is making the community one of Center City's most exciting places to live (Fig. 23). The effect of a positive attitude borne out of improvement is

16

being illustrated in this part of town as vacant lots and deteriorating structures are more often seen as opportunities rather than blight.

Unfortunately rejuvenation is often accompanied by improvement that would have left the city better off had it not occurred. Building tall in order to exploit growing commercial and residential demand is not a problem—designing badly is (Fig. 24).

Respecting the spirit of the times is a less valid architectural concept than respecting the spirit of the place.[4]

Skyscrapers began to rise up around Rittenhouse Square by the 1920s. Neighbors may have frowned upon their construction, but their grandness and desire to respect existing structure was undeniable. However, over the years skyscraper development around the square has shown an increasing penchant for inappropriate design. It need not have.

Tripartite design (base, shaft, and capital) is a basic order of most building regardless of style and is an effective approach for designing tall buildings to integrate in a low-rise context. A good base can continue established street-level design, focus attention on the bottom of a building, and diminish our visual concern with

4. Brent Brolin, *Architecture in Context* (New York: Van Nostrand Reinhold, 1980), p. 139.

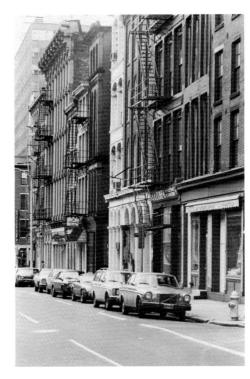

Fig. 23. Old City loft buildings. Chestnut Street, west from Second Street; north side

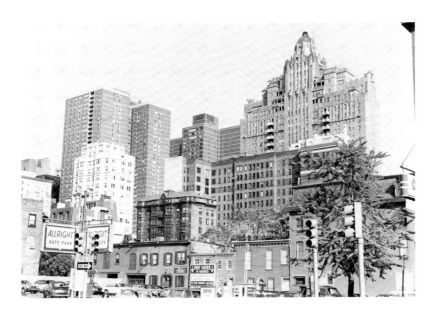

Fig. 24. Midtown; from Seventeenth and Pine Streets

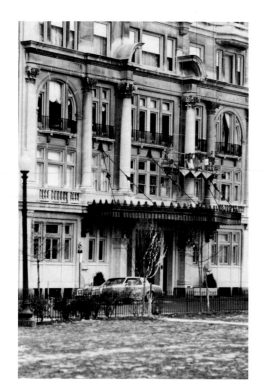

Fig. 25. 1830 Rittenhouse Square South (b. 1913)

the stories above. Built in the early part of this century, the Barclay Hotel (Plate 34) and the apartment house on 1830 Rittenhouse Square South (Fig. 25) demonstrate this; Rittenhouse Towers (Fig. 26), currently being built, does not. Rittenhouse Plaza shows further not only how to define space gracefully but also how to improve it. Its oversized, open stone gate facing Walnut Street continues the street wall formed by the building's two wings while linking a courtyard with the street and Rittenhouse Square (Fig. 27).

The issue of skyscraper design may really be more a question of whether high-rise development has been excessive. Such a determination is personal, based on one's values and point in time. The skyscraper is no less legitimate a structure in the city than the townhouse. It is an integral part of a city's character, and to think about seriously restricting or banning its development would be as arbitrary as limiting urbanization because of the problems it causes.[5]

For the visual qualities of Center City to endure, the major obstacle is not the action of redevelopment, not the construction of office towers, commercial buildings, or row houses. The city's composition is the result of rebuilding, which produces contrasting themes of old and new, residential and manufacturing, small and large, intimacy and impersonality, geometry and asymmetry, logic and disorder, warmth and coldness, naturalness and artificiality. The beauty extant today is the predictable result of builders conscious of the value of civic-minded design, who understood that

Fig. 26. Rittenhouse Towers, 210 West Rittenhouse Square (under construction)

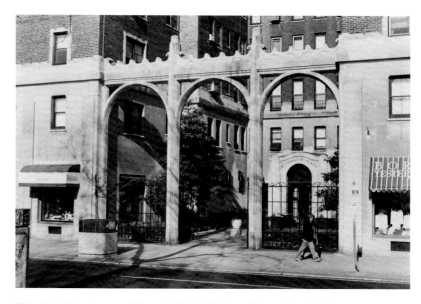

Fig. 27. Rittenhouse Plaza; 1901–5 Walnut Street (b. 1924)

18

even when a building stands by itself it does not stand alone. Thus we can find skyscrapers that do not overshadow neighboring eighteenth-century row homes because the same grace found in the latter was to be found in many early skyscrapers. The most compelling design issue is the same one that has been facing older cities around the world for some time: a desire for originality that speaks of progress and not of the past, the effect of minimalistic and abstract expression, the search for efficiency—the effect of modernism.

We want clear, organic architecture, whose inner logic will be radiant and naked, unencumbered by lying facades and trickeries; we want architecture adapted to our world of machines, radios and fast motor cars, an architecture whose function is clearly recognizable in relation to its form.

Walter Gropius[6]

To me what had been achieved . . . was the style of the century. It never occurred to me to look beyond. Here was the one and only style which fitted all those aspects which mattered, aspects of economics and sociology, of materials and function.

Nikolaus Pevsner[7]

In the last the architect has the opportunity to seek to the full the possibilities of richness and individual distinction which the contemporary style affords quite as much as the styles of the past.

Hitchcock & Johnson[8]

When half a century ago we demanded that modern architecture express "modern life," we were too innocent to guess what this demonstration would reveal. . . . What went wrong with the dreams of a truly modern style in architecture which would express the realities of our own age? Only, says a noted critic, that they came true.

Lewis Mumford[9]

With its clean, sharp lines, smooth, unadulterated surfaces, and simple, precise forms, modern architecture has an aesthetic

5. Not that these ideas do not merit consideration.

6. Charles Jencks, *Modern Movements in Architecture* (New York: Anchor Books/Doubleday, 1973), p. 109. Spoken in 1923.

7. Nikolaus Pevsner, "Architecture in Our Time, the Anti-Pioneers," *Listener*, 29 December 1966, p. 953.

8. Henry-Russell Hitchcock and Philip Johnson, *The International Style* (New York: Norton & Co., Inc., 1932), p. 55.

9. Mumford, *Architecture as a Home for Man*, p. 152.

Fig. 28. St. James House, 1226–32 Walnut Street (b. 1901–4)

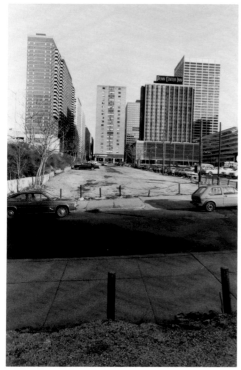

Fig. 29. John F. Kennedy Boulevard; east from Twenty-first Street

quality (Plates 20, 47). It expresses a purity that goes beyond the traditional elements of style, involving the nature of materials and a no-nonsense attitude toward the purpose of structure. Modern design has been able to give building a new, sometimes acrobatic look through the constant refinement of materials and structural systems. However, design has too often been subordinate to the efficient use of evolving technology, resulting in modern architecture's failure to focus its appearance, as buildings seem to fail to face onto the street.

One reason modernists condemned the eclectic styles of nineteenth-century and early twentieth-century building was because the exposure of their untreated sides (Fig. 28) revealed how unrelated their façades actually were to their structures.

So bad in every way have been the façades of most American commercial edifices that their rear elevations, which are at best merely sound building, seem by contrast to possess architectural quality.[10]

Ironically, in solving the problem (at least with façades they thought bore more truth to their structures' nature) modernists ended up treating the sides of their buildings all too equally, effectively removing the structure from the streetscape by turning its attention vaguely somewhere else, if anywhere at all (Fig. 29). The aesthetics of modernism, dominated by an often banal concern for

Fig. 30. Market East. A conception of the plan
Courtesy of Bower Lewis Thrower/Architects, Cope Linder Associates.

20

volume, material beauty, and regularity, explain why most building from this architectural period fails to integrate into our older cities' streets.[11]

When architecture's leaders redefine good design, does it tell of the decline of existing style? Not necessarily. But it may suggest how well our cities will endure. Architectural critics and historians are recognizing a new stage or stages of modernism, referring to it as Late and Post Modernism. We are beginning to see designs that show a greater concern for more distinct and imaginative styling, perhaps reflecting a trend that is considering architecture to be more than the expression of form. In Center City, the Scott Administration and Library Building of Thomas Jefferson University (Fig. 31) may be a slightly awkward piece of Romanesque-style architecture, but the attempt at reviving a historical image is welcomed. The design of the Fidelity Mutual Life Building (Fig. 32) is not far removed from traditional modern design, but its rich color and texture suggest an elegance similar to that found in earlier stone skyscrapers, while its keystoned windows and accented top bring further attention to the façade. The restoration of commercial façades along Chestnut and Walnut Streets also reflects an integration of nineteenth- and twentieth-century aesthetics. With the assistance of municipal design guidelines, the bases of the American Baptist Publication Society Building (Fig.33), the Victory Building, 1425 and 1526 Chestnut Street, involving as many as three stories, have been redesigned, stripping ostentatiousness and restoring architectural integrity, giving the buildings and their streets a more refined appearance.[12]

Perhaps the most fascinating example of more innovative design in Center City ironically utilizes the traditional glass box

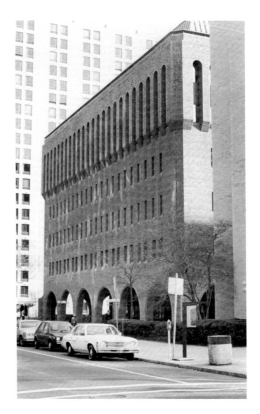

Fig. 31. Scott Administration and Library Building, 1020 Walnut Street (b. 1970)

10. Hitchcock and Johnson, *The International Style*, p. 79.

11. Modernism's failure to make the street a unified and desirable space may be a factor in the development of large interior pedestrian spaces where the total environment can be designed. In speaking of the new pedestrian space being integrated into the redevelopment of Market Street East (Fig. 30), Edmund Bacon described it as:

a new kind of people street, paralleling and reinforcing vehicle-laden Market Street, providing a new kind of experiential continuity in Center City. . . . I believe that, when the project is completed, it will have been decisively demonstrated that the significant architecture actually is contained in the people street and its movement systems, and that the architectural expression of the several buildings along it, each of which may be developed by a different owner with a different architect, hopefully of a high architectural order, nevertheless will be subordinate in importance to the people street.

(Edmund Bacon, *Design of Cities* [New York: Penguin Books, 1976], pp. 294–95.)

12. Philadelphia City Planning Commission, "Façade and Sign Guidelines, Draft for Review," June 1982.

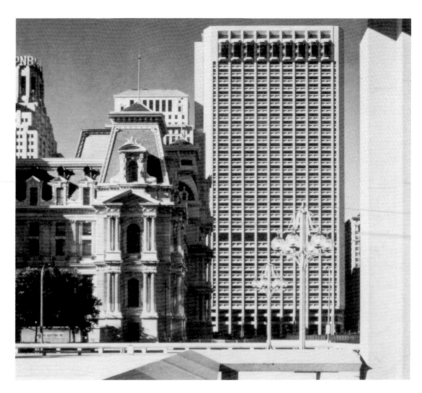

Fig. 32. Fidelity Mutual Life Building (Three Girard Plaza), Fifteenth Street and South Penn Square (b. 1973)
Photograph by Lawrence S. Williams. Courtesy of The Kling Partnership.

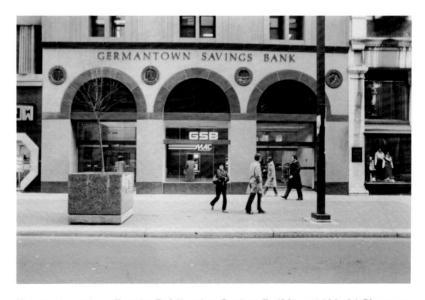

Fig. 33. American Baptist Publication Society Building, 1420–24 Chestnut Street (renovated 1981)

but on such a small scale as to be playful. NewMarket (Fig. 34), at Pine between Front and Second Streets, is a mixed-use development, combining rehabilitation and new building, rustic and modern materials, and a layout that is a multilevel pedestrian labyrinth to create a visually dynamic place. NewMarket reflects imaginative thinking that respects the commercial tradition of the waterfront and contemporary demands.

Though some recent architecture is rediscovering that individual design can be artistic and sympathetic to its context while being contemporary, it is still by no means characteristic of building today. However, it does indicate that modern architecture is not static, that it is capable of responding to criticism. It is acknowledging the usefulness of integrating new ideas with the successful accomplishments of the past in beginning to realize that, like all of man's breakthroughs, modern architecture is only part of a larger ongoing phenomenon. As it evolves, we can hope that architecture and the attitudes shaping it will respond favorably to places like Center City, where structure and space have created aesthetic compositions.

It (1949) is the date when Philip Johnson began to give his splendid talks which those of us who first heard them regarded almost as the pronouncements of the Devil. He stood up on the platform at Yale University and he said to a shocked hush across the room, "I would rather sleep in the nave of Chartres Cathedral with the nearest John two blocks away than I would in a Harvard House with back to back bathrooms." This terrible and even rather frightening pronouncement was the one after which, for the first time, I remember students saying to me, "He's talking about architecture as an art." And suddenly I realized that that is what it was all the time.

Vincent Scully[13]

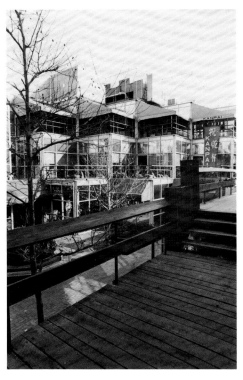

Fig. 34. NewMarket, Second and Pine Streets (b. 1974)

13. Charles Jencks, *Modern Movements in Architecture,* p. 189.

Plates

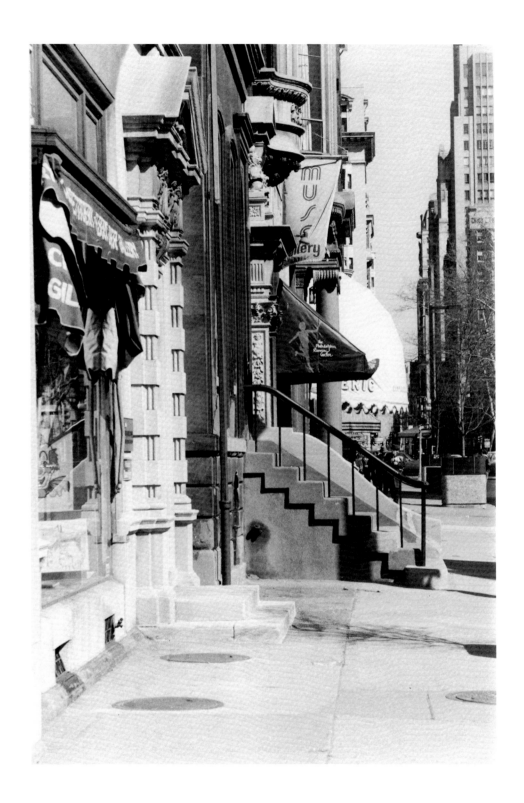

1. Walnut Street

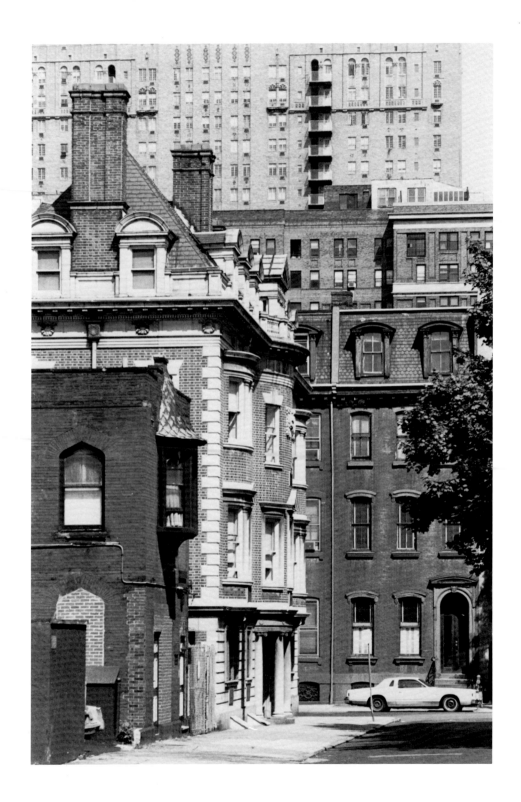

2. Delancey Street

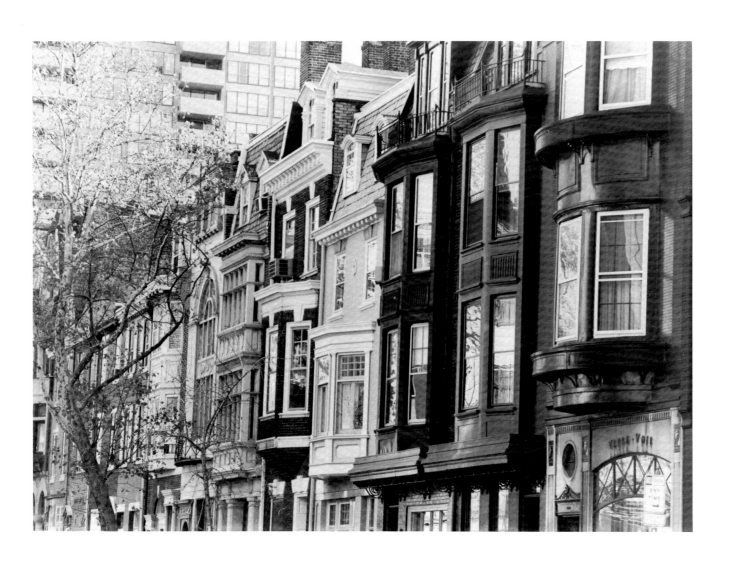

3. Locust Street

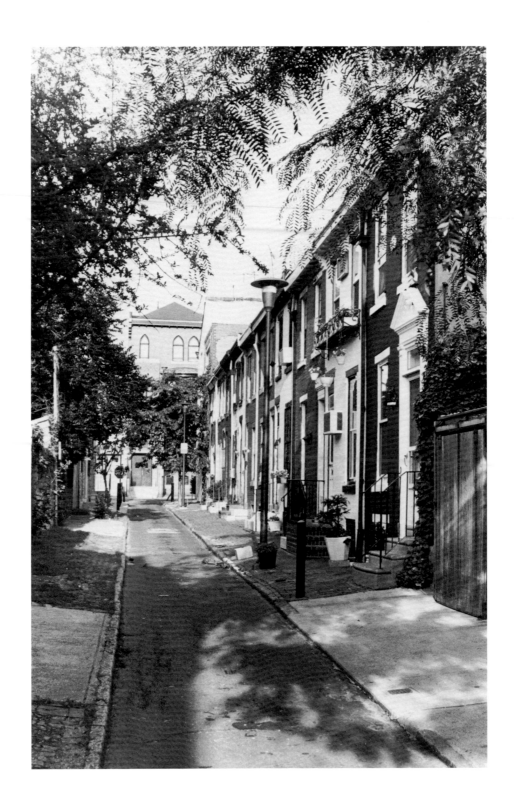

4. Manning Street

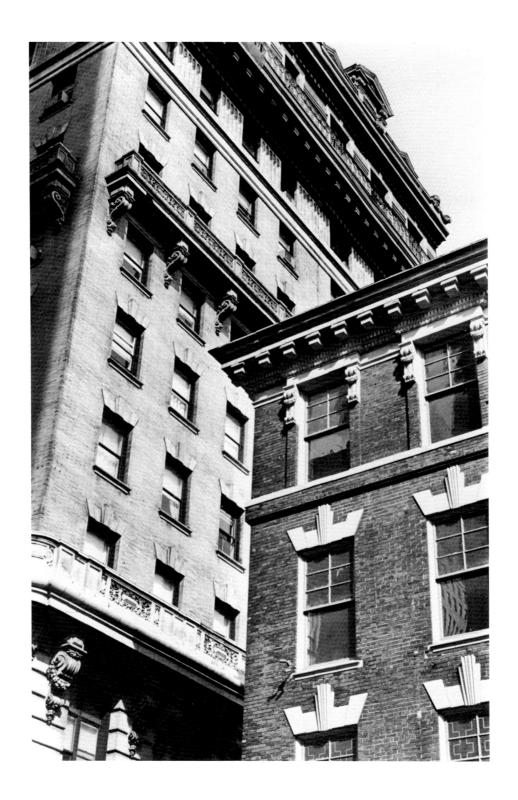

5. St. James House

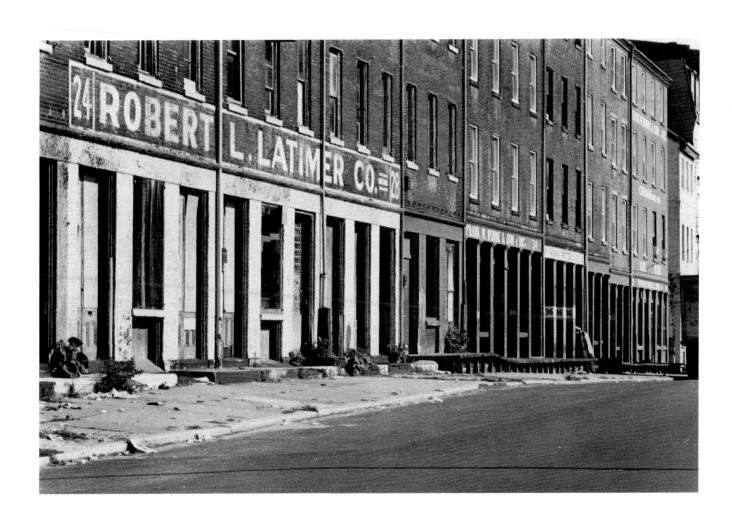

6. North Front Street

7. 128–30 Chestnut Street

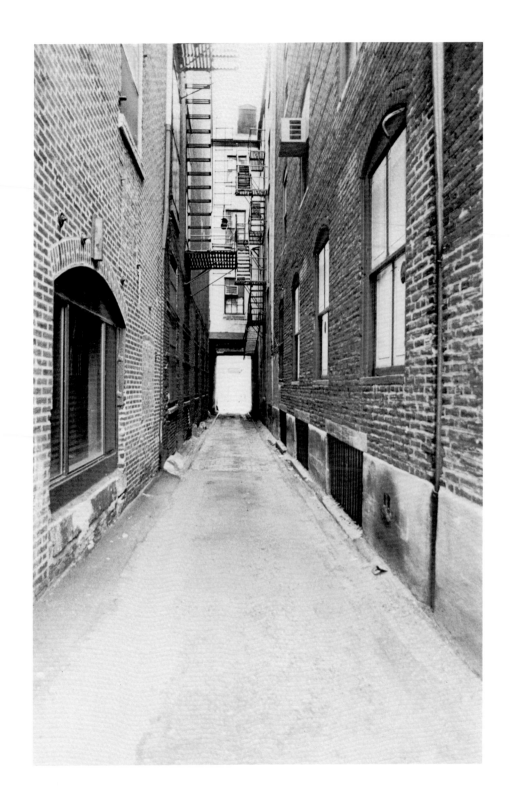

8. Filbert Street

9. 2104 Spruce Street

10. Reading Terminal and hotel

11. City Hall

12. Logan Square

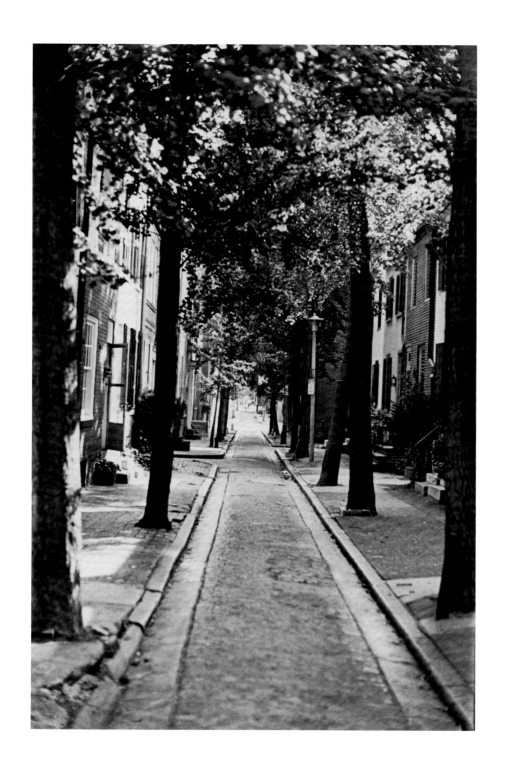

13. Quince Street

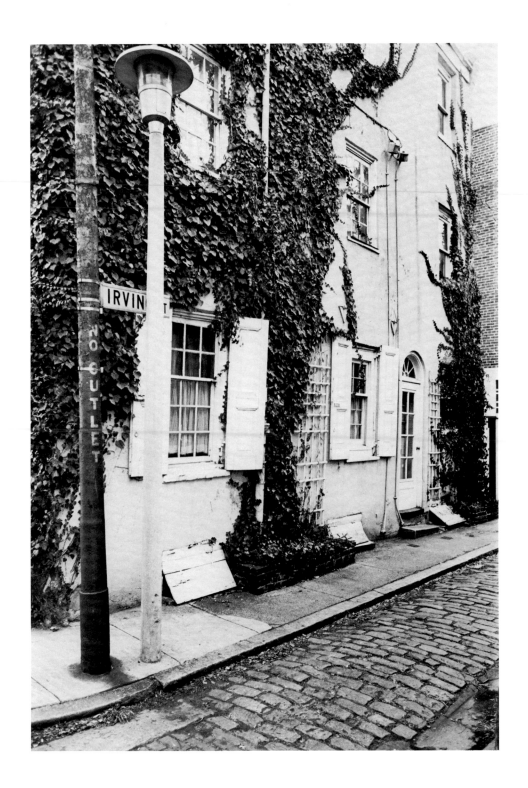

14. 1102 Irving Street

15. Independence National Historical Park

16. Bankers Row

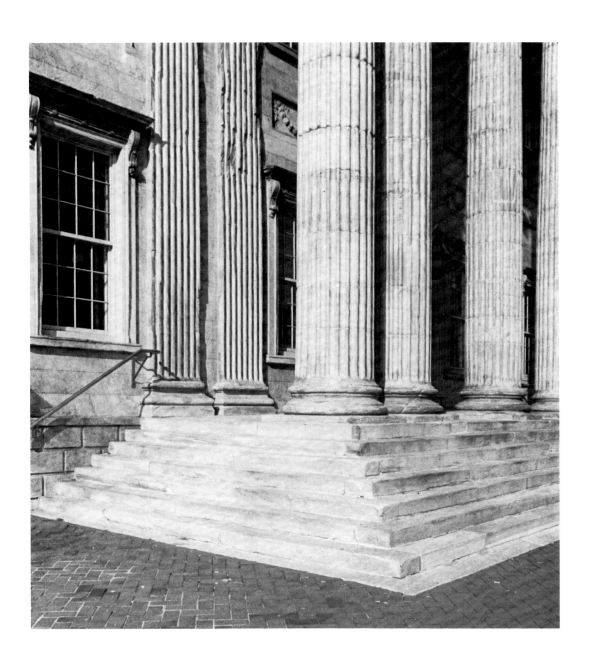

17. First Bank of the United States

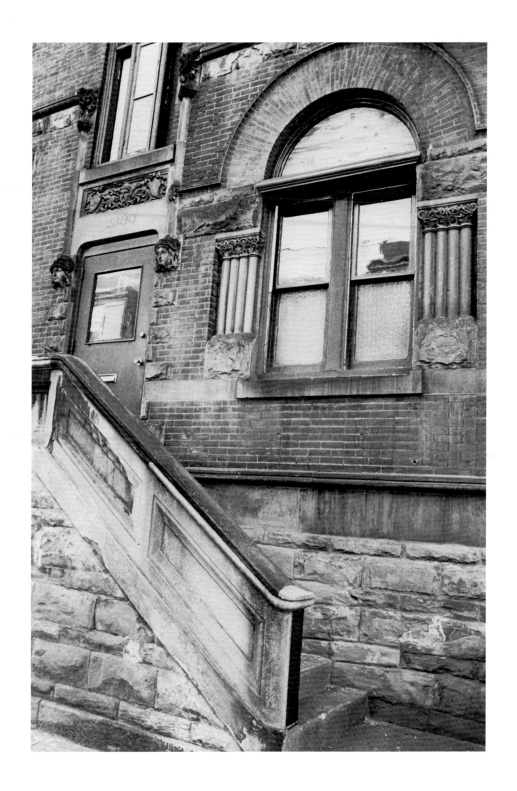

18. 2300 Locust Street

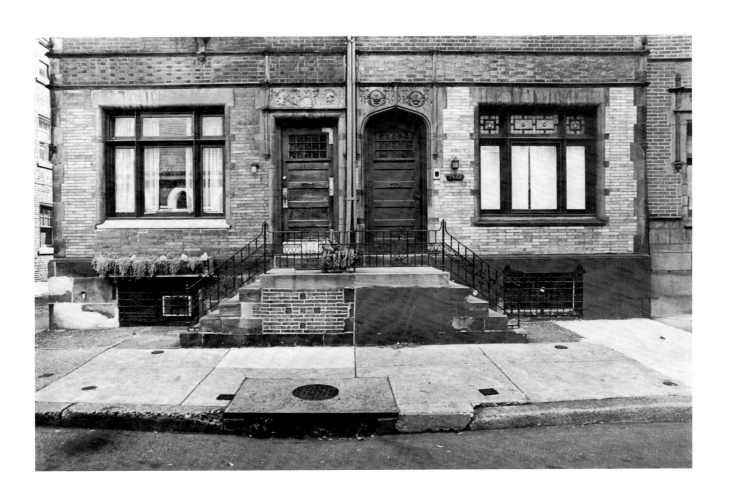

19. 1920–22 Pine Street

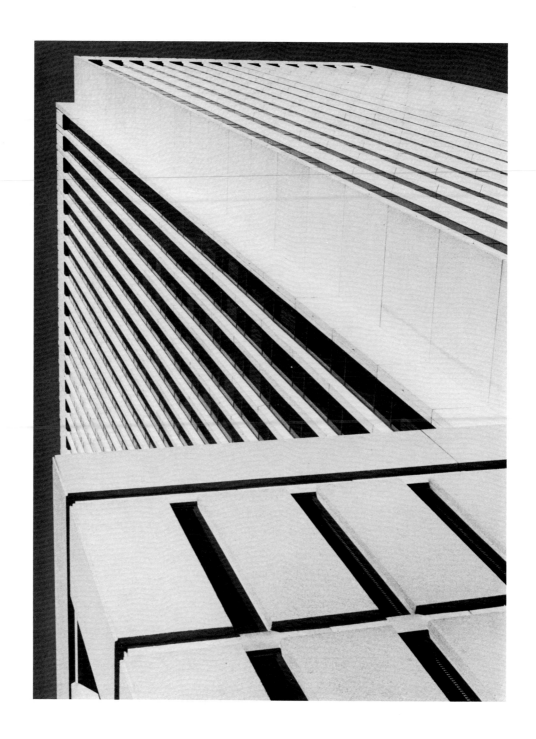

20. Mutual Benefit Life Building

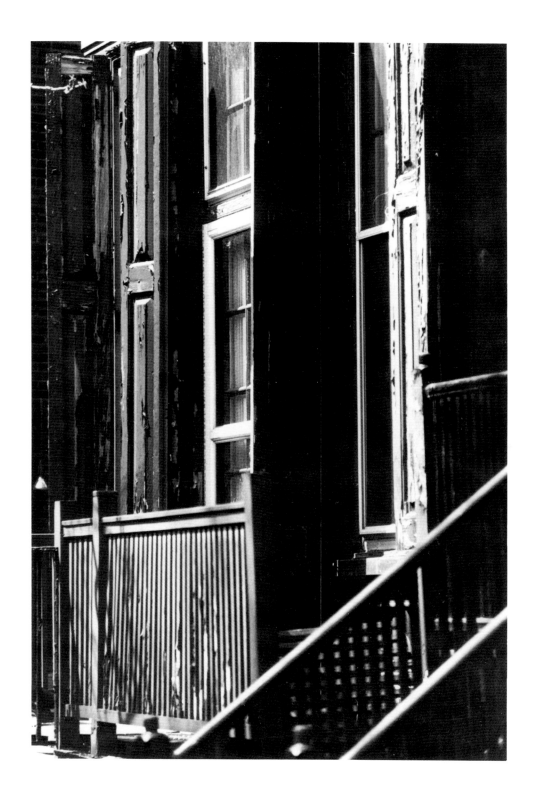

21. 2102 Spruce Street

22. Elfreths' Alley and Bridge

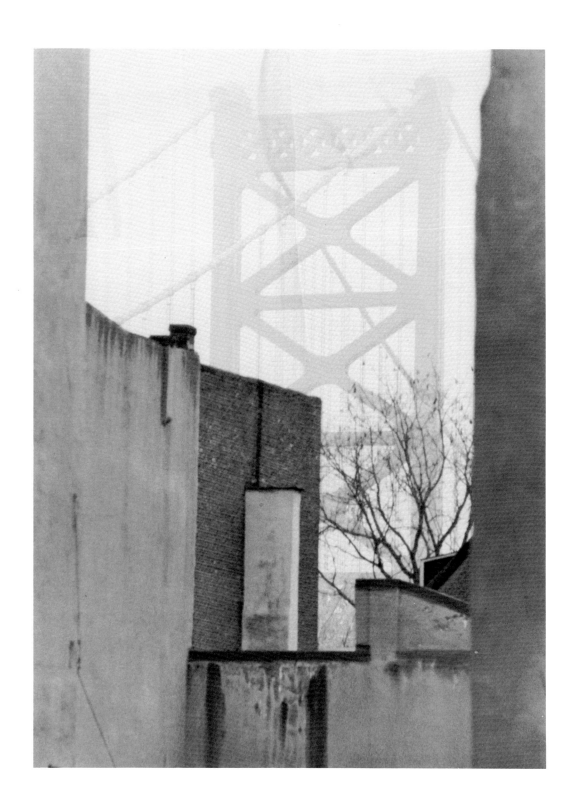

23. Benjamin Franklin Bridge

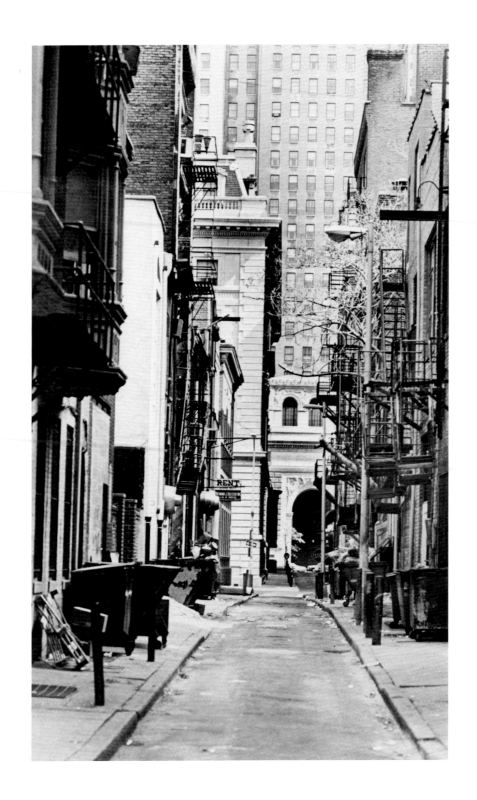

24. Moravian Street

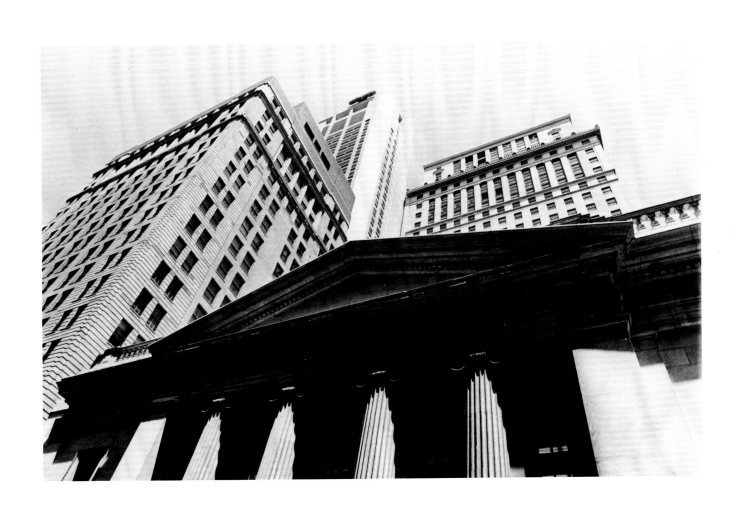

25. Girard Trust Company Building

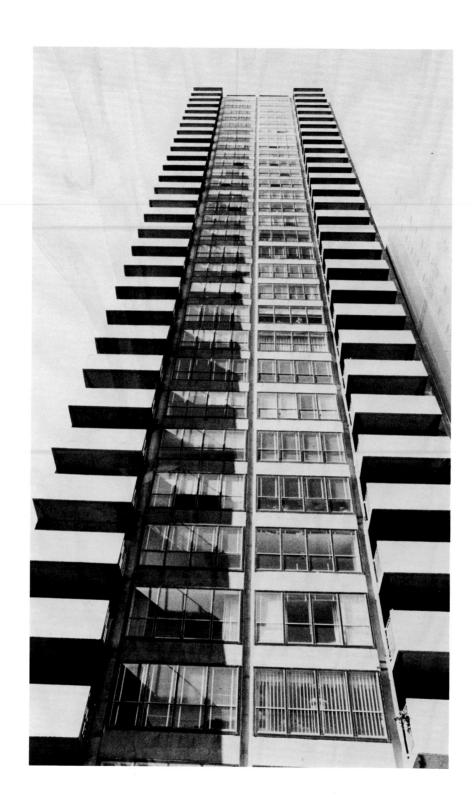

26. The Dorchester

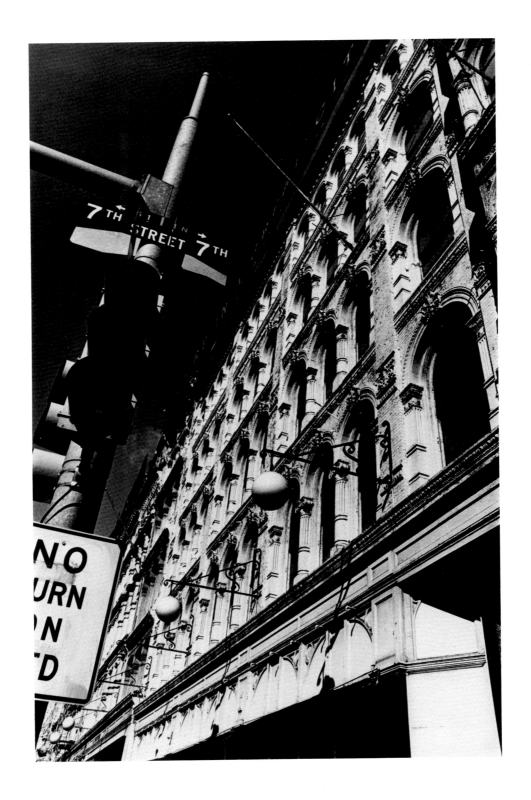

27. Lit Brothers

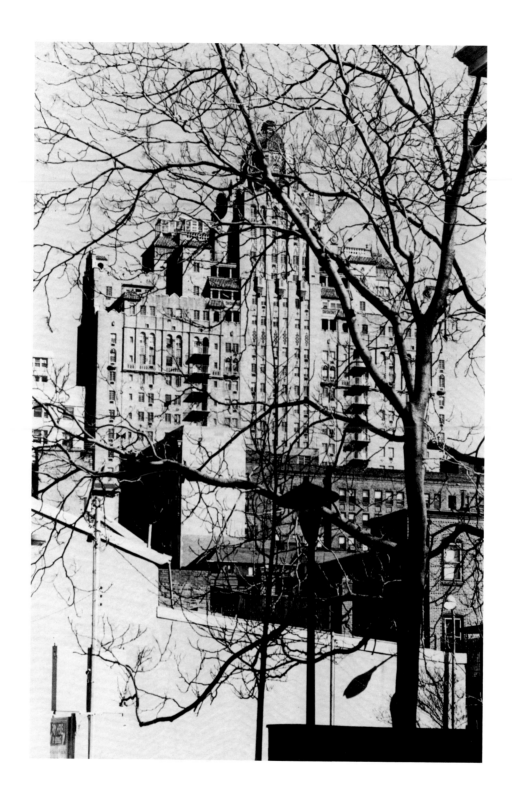

28. The Drake Hotel

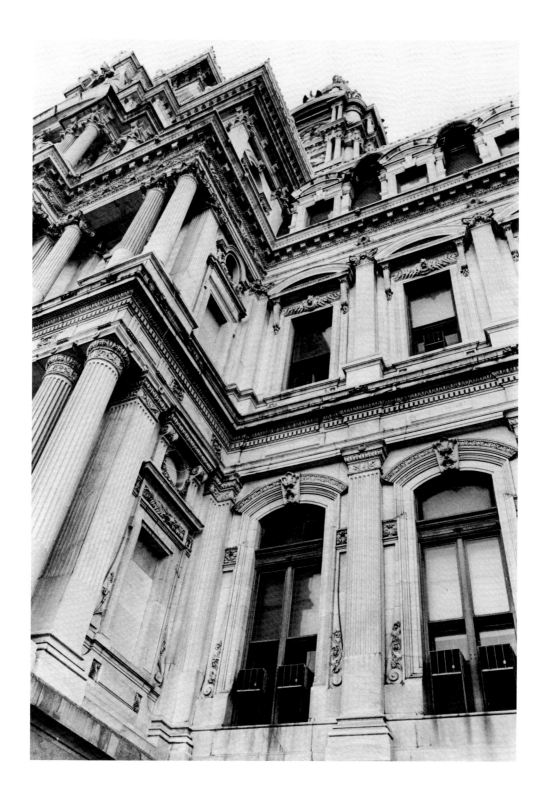

29. City Hall

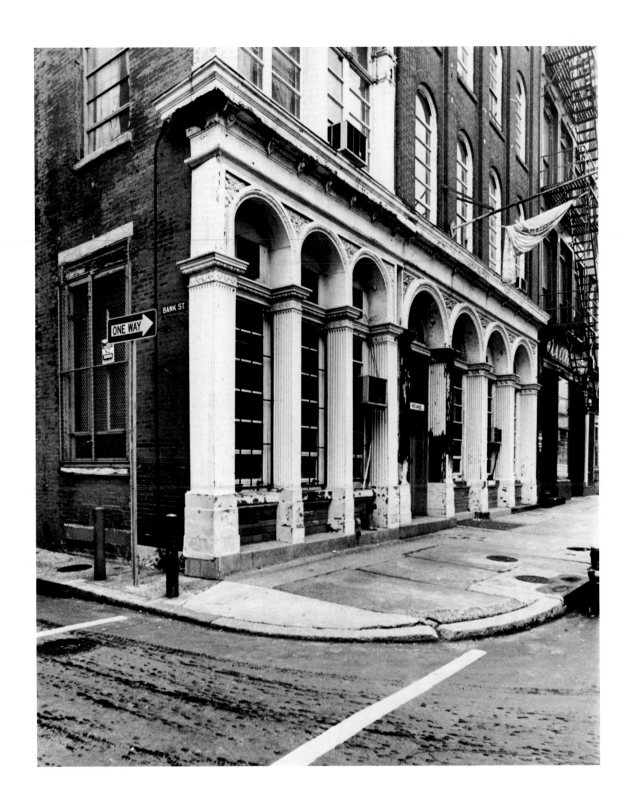

30. Corner of Bank and Chestnut Streets

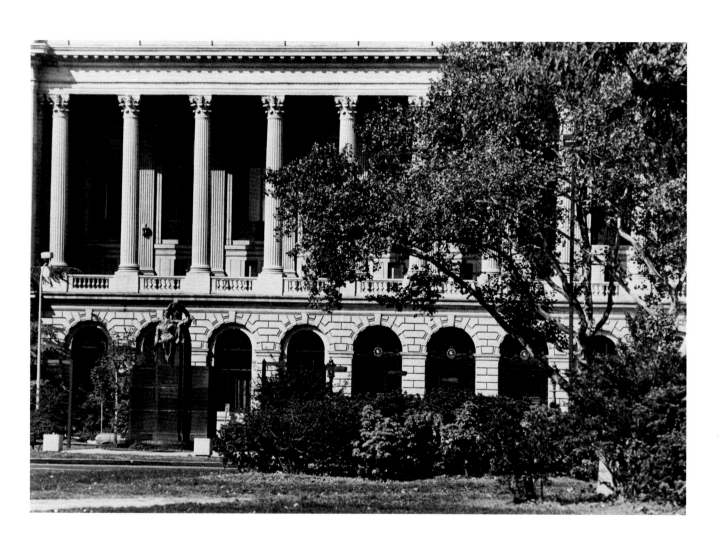

31. Free Library of Philadelphia

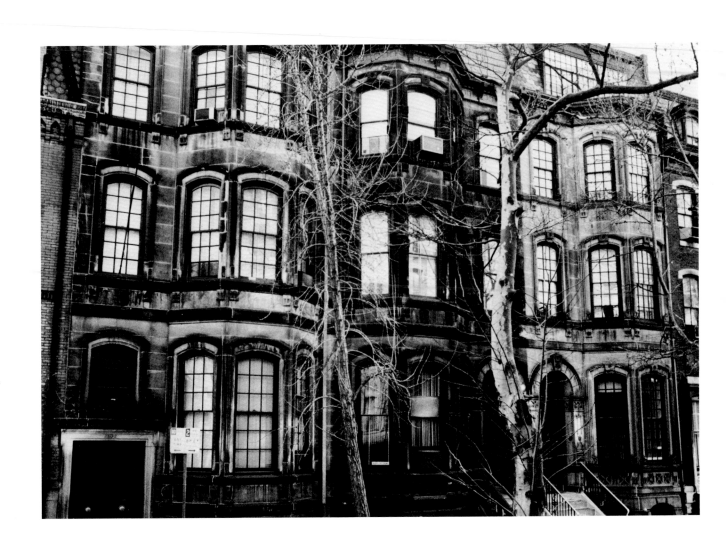

32. 2102–6 Spruce Street

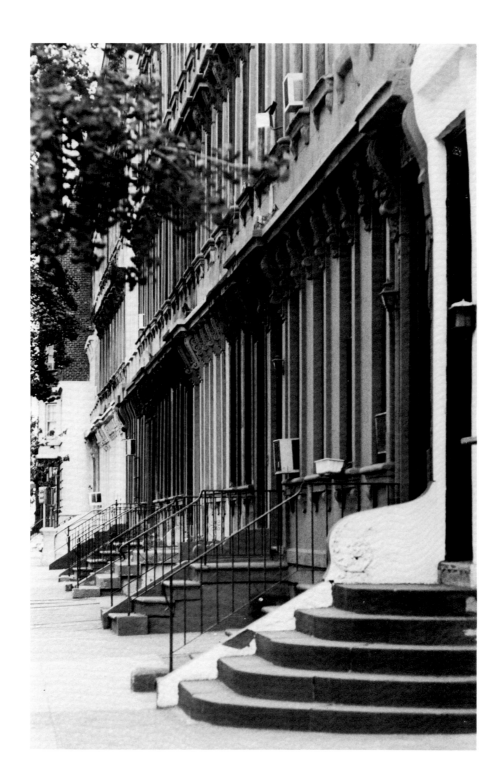

33. Union Row

34. The Barclay

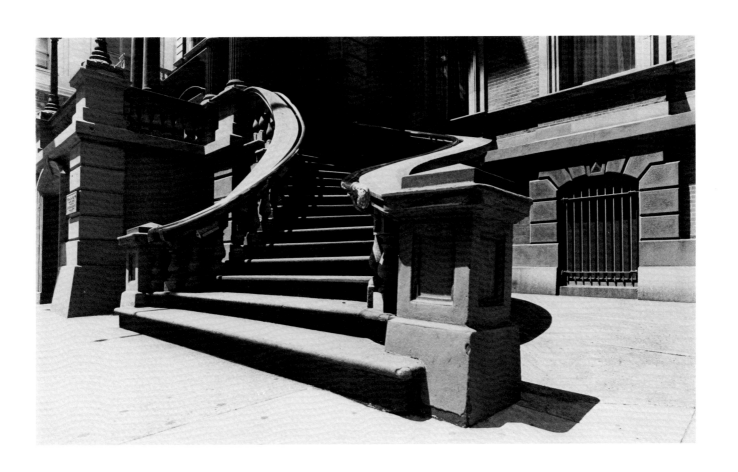

35. The Union League of Philadelphia

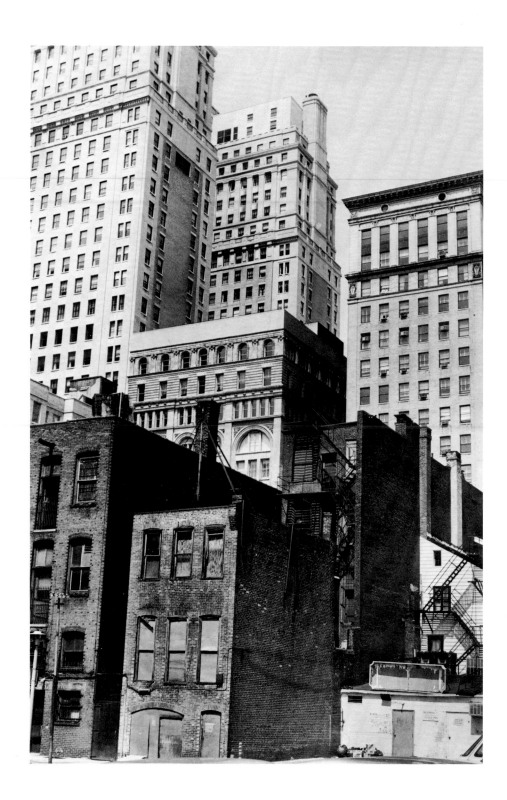

36. Walnut Street

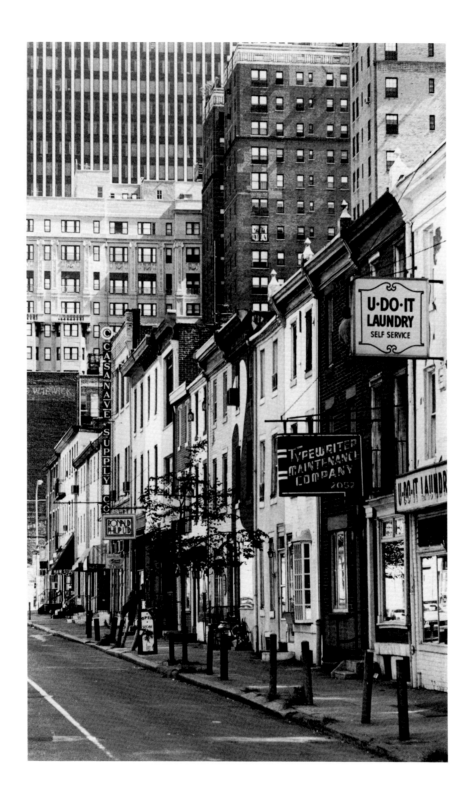

37. Sansom Street

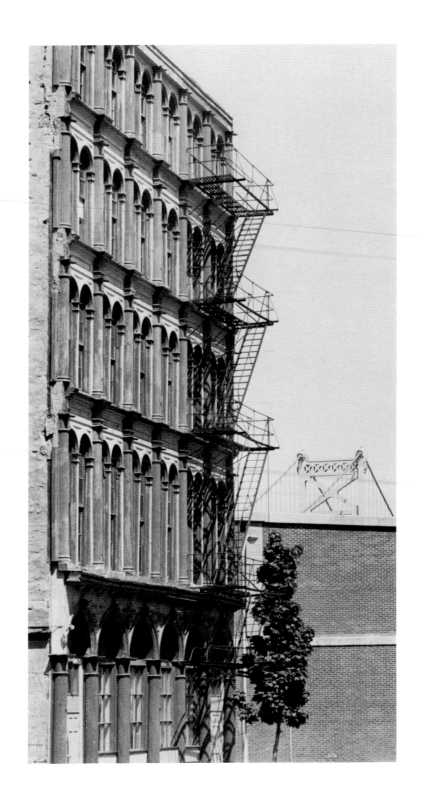

38. 103–5 Arch Street

39. Corner of Third and Arch Streets

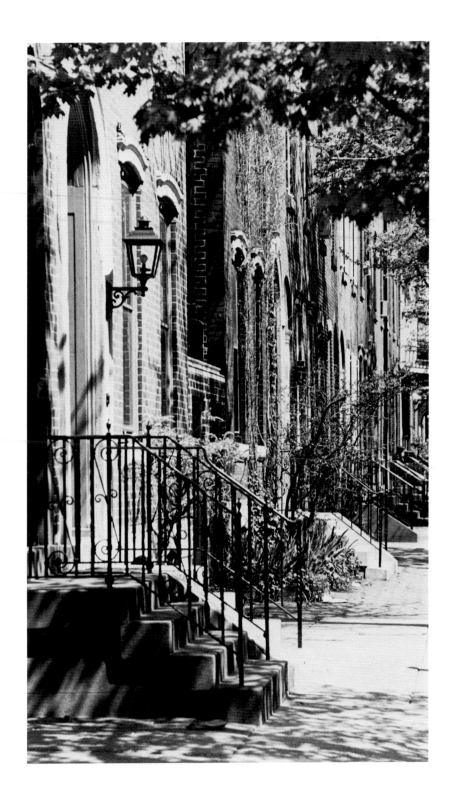

40. Pine Street

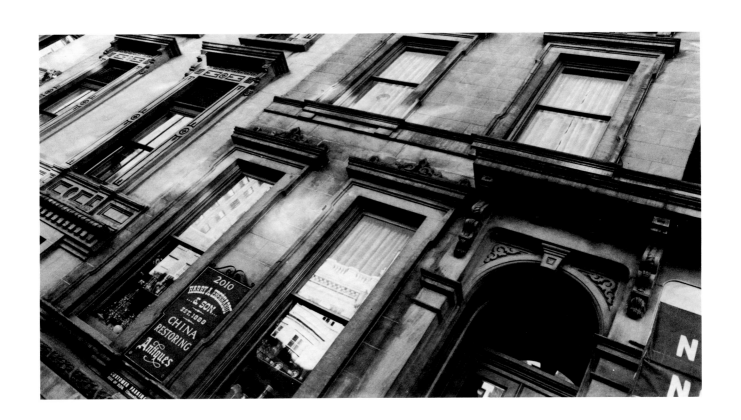

41. 2006–10 Walnut Street

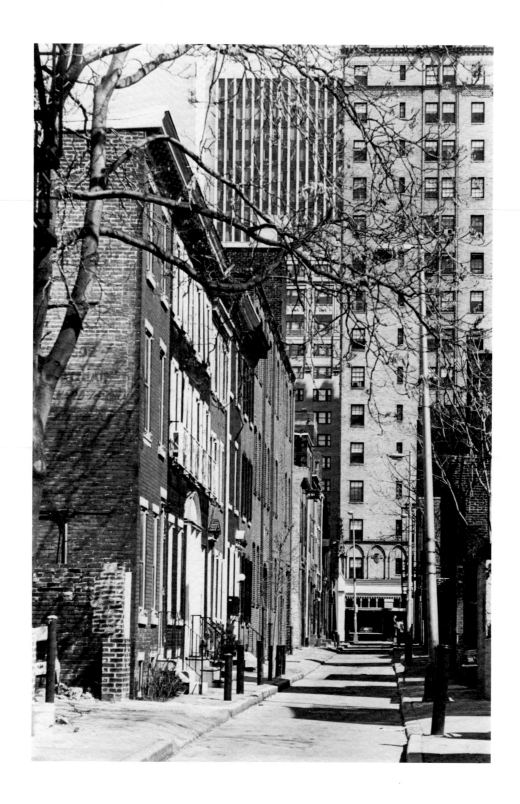

42. Moravian Street

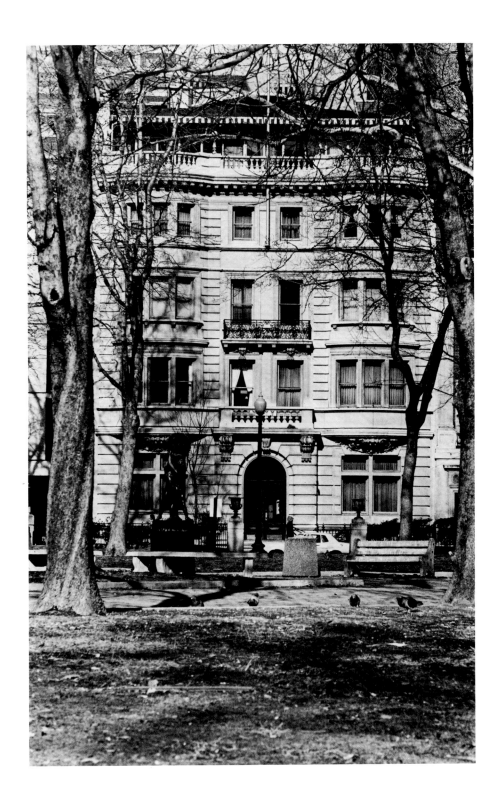

43. The Rittenhouse Club

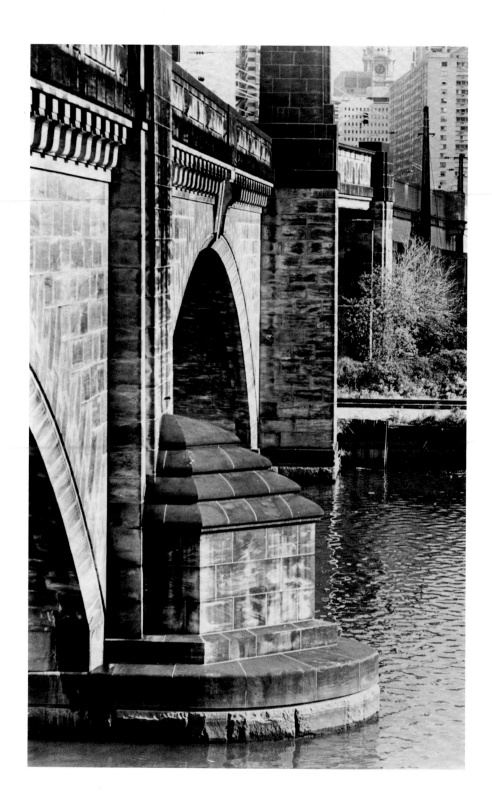

44. Pennsylvania Railroad Bridge

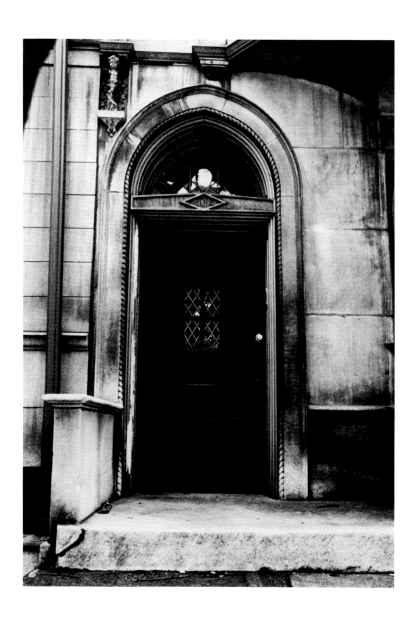

45. 2012 Pine Street

46. Cathedral of Saints Peter and Paul

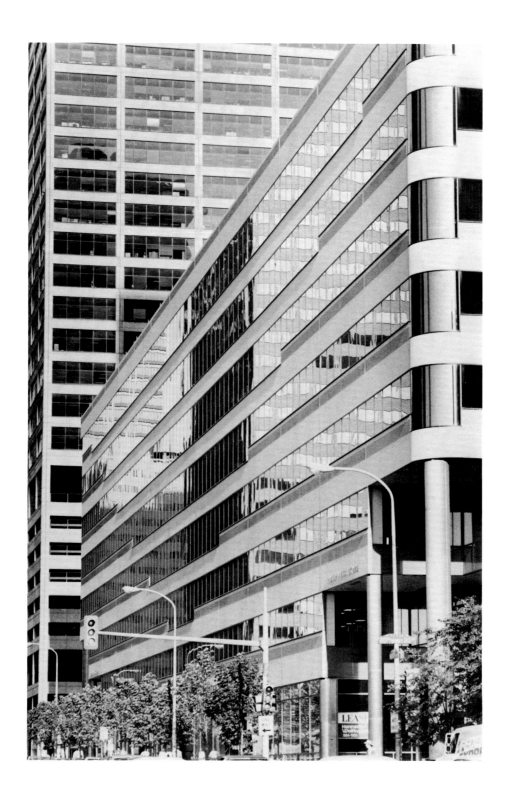

47. The Philadelphia Stock Exchange Building

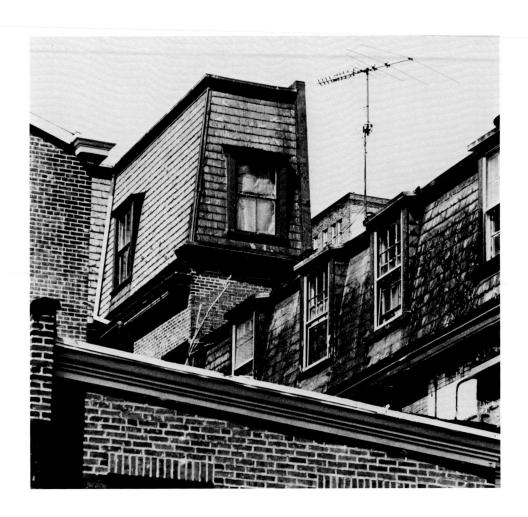

48. 1722 Spruce Street

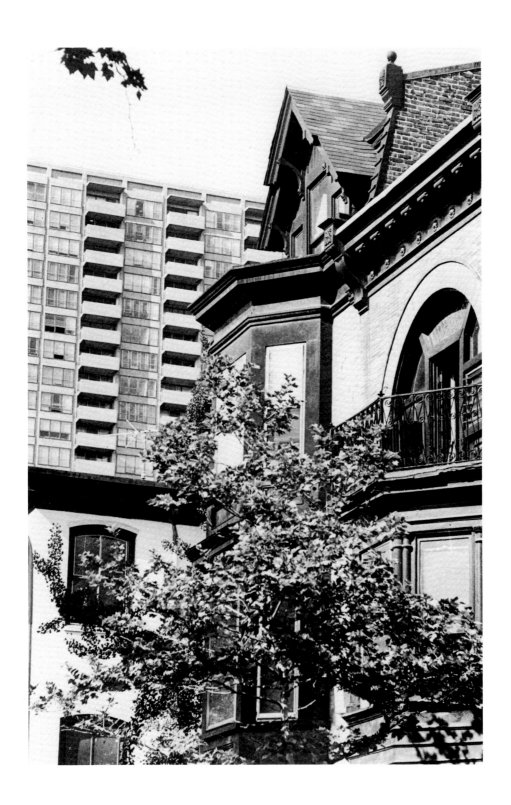

49. South Twentieth Street

50. The Philadelphia Art Alliance

51. 2221 St. James Place

52. 2023 Walnut Street

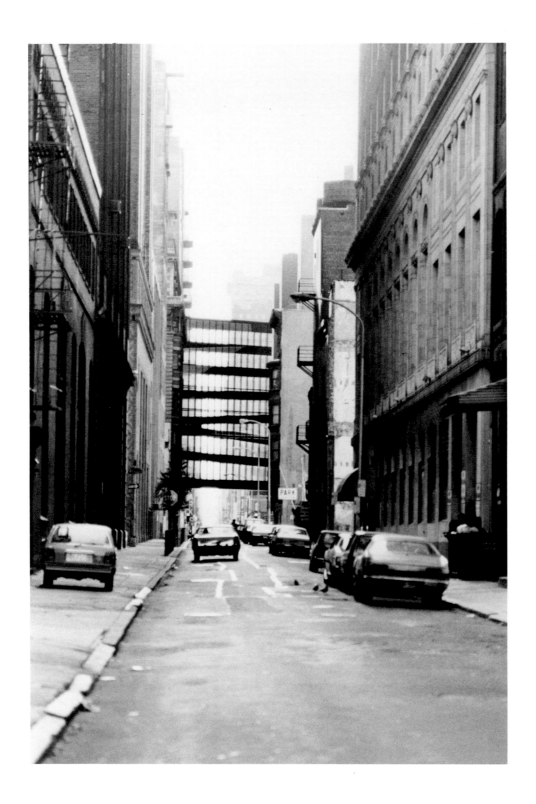

53. Sansom Street

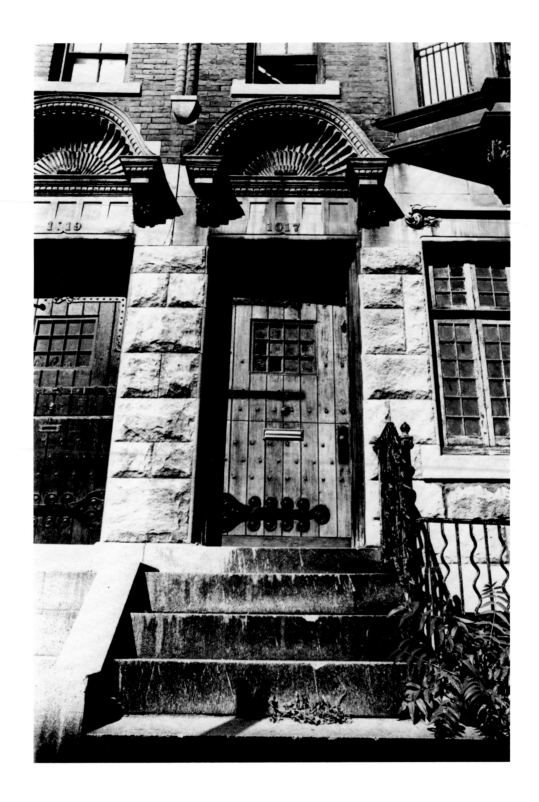

54. 1017 Spruce Street

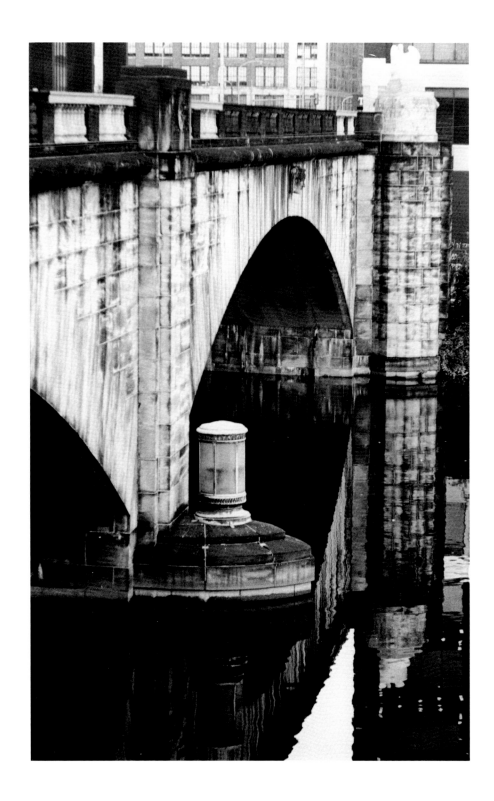

55. Market Street Bridge

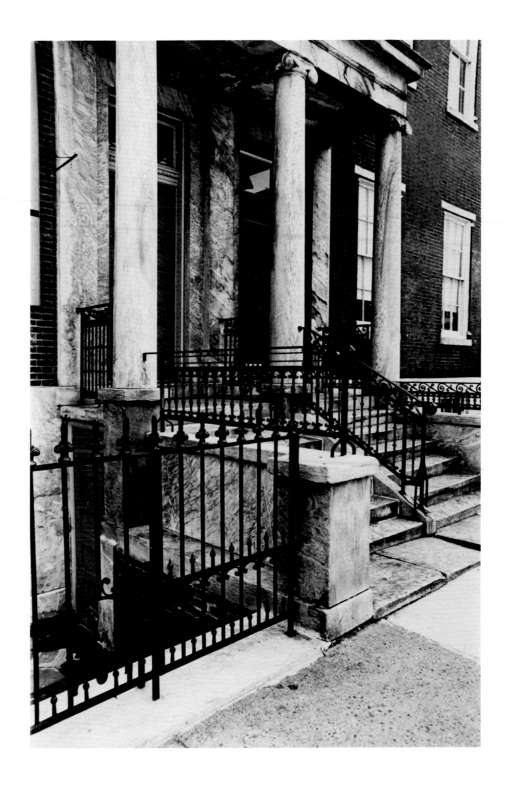

56. Portico Row

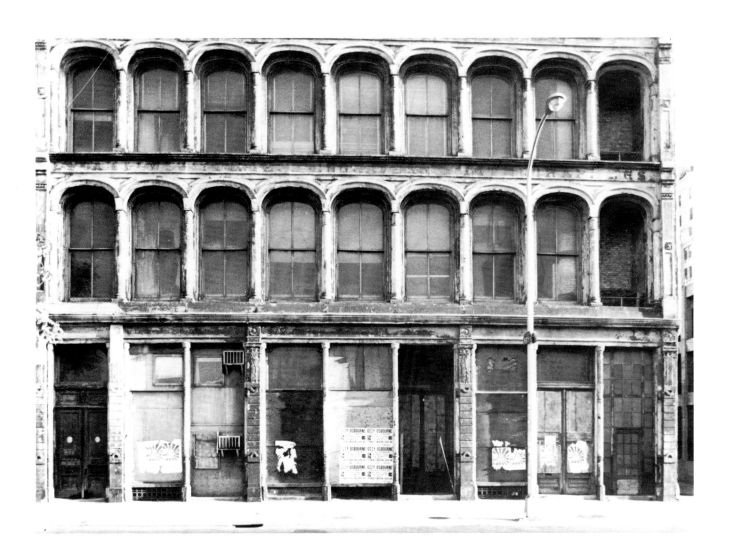

57. Lit Brothers

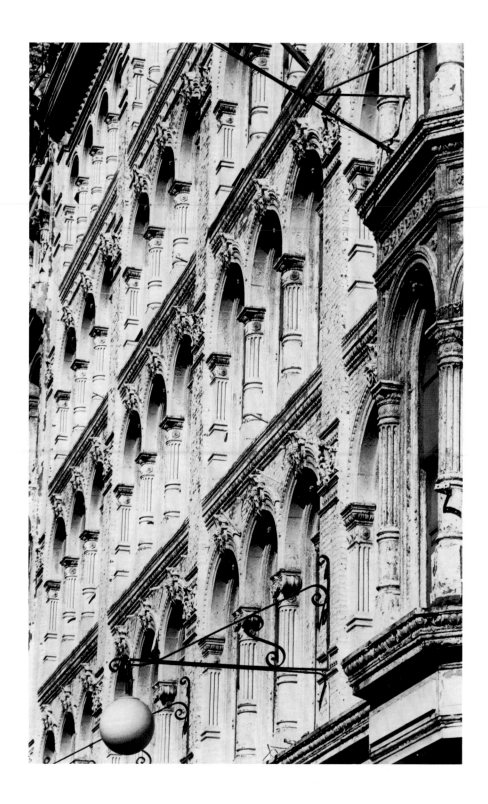

58. Lit Brothers

59. The Eldorado

60. 2132 Spruce Street

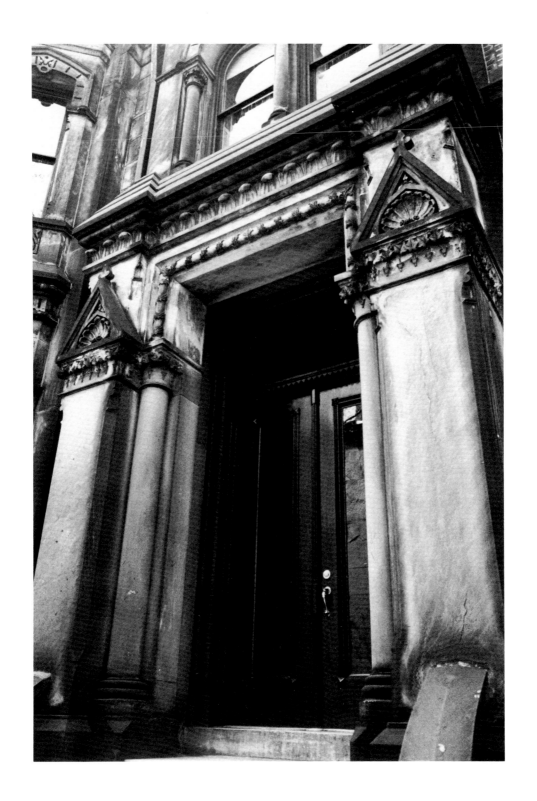

61. 2038 Spruce Street

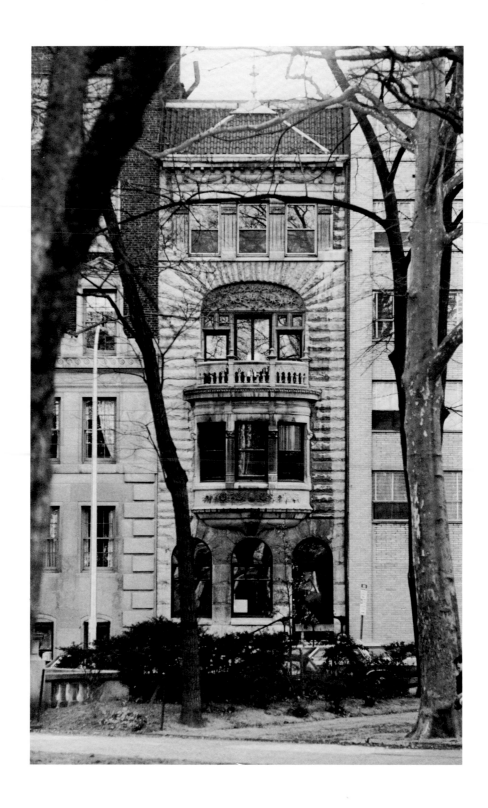

62. 1804 Rittenhouse Square South

63. West Arch Street Presbyterian Church

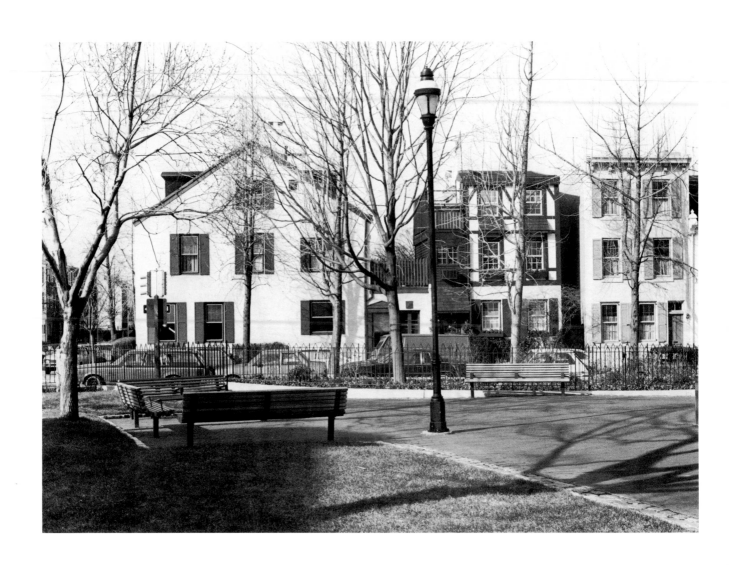

64. Fitler Square

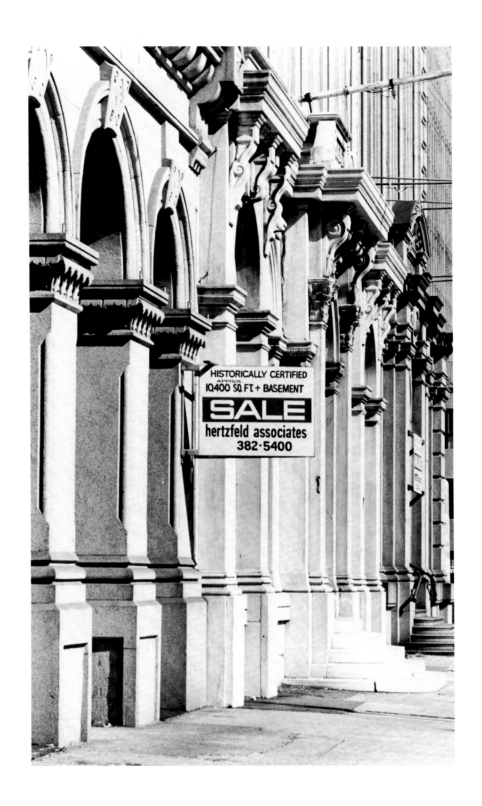

65. Bankers Row

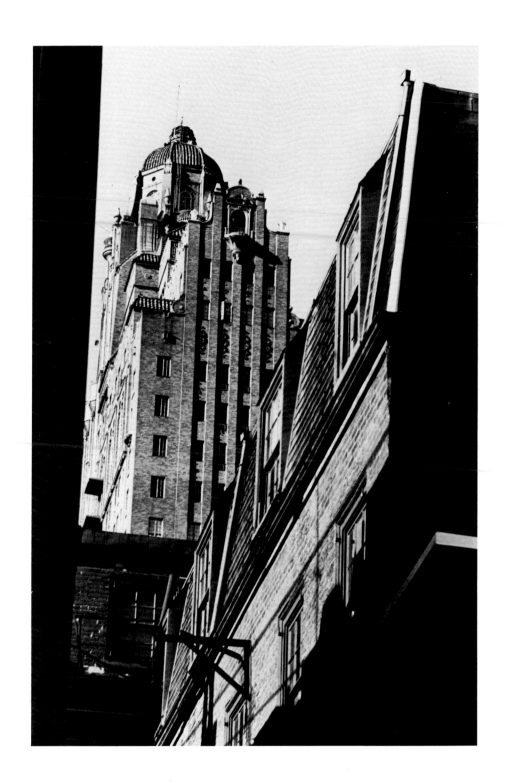

66. The Drake Hotel

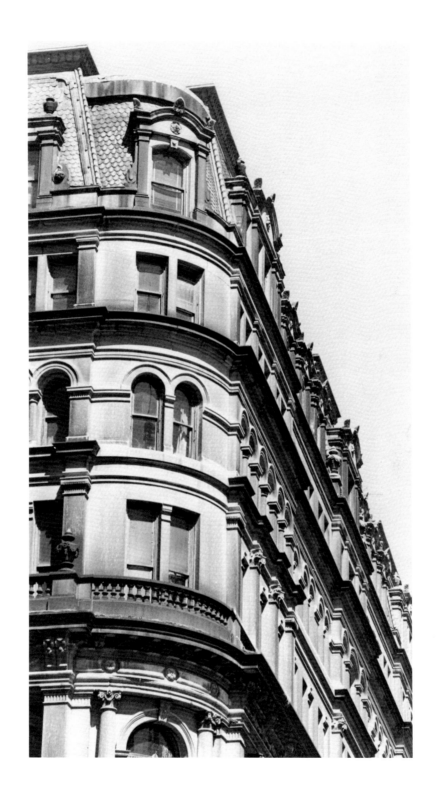

67. Victory Building

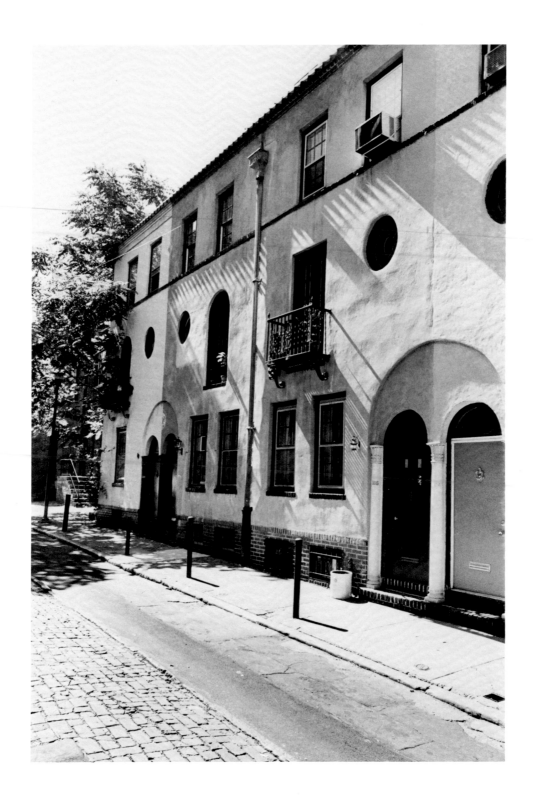

68. Sansom Gardens

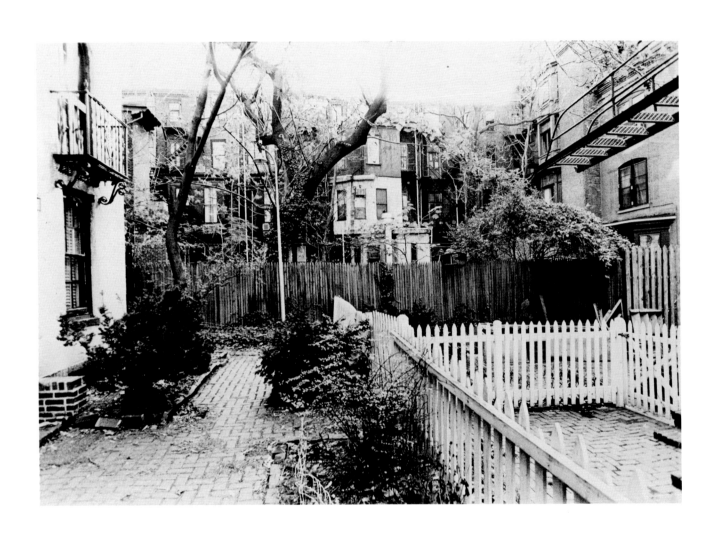

69. Beechwood Street

70. The General Store

71. Eduardo's

72. Corner of Seventeenth and Locust Streets

Appendix

Plate No.	Building · Address	Date Built	Architect
1	1900 block of Walnut Street		
2	Delancey Street; east of Eighteenth Street		
3	2000 block of Locust Street		
4	2200 block of Manning Street		
5	St. James House, 1226–32 Walnut Street	1901–4	Horace Trumbauer
6	24–42 North Front Street	ca. 1828–36	
7	128–30 Chestnut Street		
8	Filbert Street; west to Third Street		
9	Backyard, 2104 Spruce Street	1860	Hewitt and Furness (?)
10	Reading Terminal, Twelfth and Market Streets	1891–93	Francis Kimball
11	City Hall; South Broad Street	1871–1901	John McArthur, Jr.; Thomas U. Walter, consultant; Alexander Milne Calder, sculptor
12	Logan Square	1823; altered 1918	Jacques Gréber
13	Quince Street; south from Locust Street		
14	1102 Irving Street		
15	Independence National Historical Park		
16	Bankers' Row; 400 block of Chestnut Street:		
	421 Chestnut Street (originally Bank of Pennsylvania)	1859; altered 1900	John M. Gries Theophilus Chandler
	427 Chestnut Street (originally Farmers and Mechanics Bank)	1855	John M. Gries
	431 Chestnut Street (originally Pennsylvania Company for Insurance on Lives and Granting Annuities)	1873	Addison Hutton
17	First Bank of the United States, 120 South Third Street	1795	Samuel Blodgett, Jr.
18	2300 Locust Street		
19	1920–22 Pine Street	1889	Frank Miles Day

I would like to thank Ms. Patricia Siemiontkowski and Ms. Sally Elk of the Philadelphia Historical Commission for retrieving most of the data listed herein from the commission's files. Building information has been supplied to the commission from various sources.

103